Captain W.E. Johns Mary Norton Rosemary Sutcliff William Mayne Dodie Smith Anthony Buckeridge C.S. Lewis Edward Ardizzone Noel Streatfeild J.R.R. Tolkien Kathleen Hale Enid... ...na Ross The Revd W.V. Awdry

D0895341

Beatrix Potter to Harry Potter

Portraits of children's writers

Eastwood Dunkeld
Sep 4th 93

My dear Noel,
 I don't know what to
write to you, so I shall tell you a story
 about four little rabbits.
 whose names were—

Flopsy, Mopsy Cottontail

and Peter

They lived with their mother in a
sand bank under the root of a
big fir tree.

Beatrix Potter to
Harry Potter

Portraits of children's writers

Julia Eccleshare

FOREWORD BY ANNE FINE

NATIONAL PORTRAIT GALLERY

Published in Great Britain by National Portrait Gallery Publications,
National Portrait Gallery, St Martin's Place, London WC2H 0HE

Published to accompany the exhibition *Beatrix Potter to Harry Potter:
Portraits of children's writers* held at the National Portrait Gallery,
London, from 15 May to 26 August 2002, Durham Art Gallery,
from 14 December 2002 to 26 January 2003, and Hove Museum and
Art Gallery, from 10 April to 10 June 2003.

For a complete catalogue of current publications
please write to the address above, or visit our website at
www.npg.org.uk/publications

Copyright © Julia Eccleshare, 2002
Foreword © Anne Fine, 2002

The moral right of the author has been asserted. All rights reserved.
No part of this publication may be reproduced, stored in a retrieval
system or transmitted in any form or by any means, whether
electronic or mechanical, including photocopying, recording
or otherwise, without the prior permission in
writing of the publisher.

ISBN 1 85514 342 9

A catalogue record for this book is available from the British Library.

Project Editor: Susie Foster
Editor: Celia Jones
Production: Ruth Müller-Wirth
Design: Price Watkins Design
Printed by Butler & Tanner Limited, England

The publisher would like to thank the copyright holders for granting
permission to reproduce works illustrated in this book. Locations
and lenders are given in the captions, and further acknowledgements
are given in the picture credits at the back of the book. Every effort
has been made to contact the holders of copyright material, and any
omissions will be corrected in future editions if the publisher is
notified in writing.

Front cover: A.A. Milne with Christopher Robin Milne and
 Pooh Bear, Howard Coster, 1926
Back cover: Illustration by Quentin Blake for *The Dahl Diary 1992*
Frontispiece: Letter from Beatrix Potter to Noel Moore,
 4 September 1893

Supported at the National Portrait Gallery by PEARSON

Contents

Acknowledgements

THIS book is based on an exhibition celebrating the achievements of a century of children's authors. The writers have been selected by exhibition curators Michèle Brown and Gyles Brandreth, whose choices were inspired by their own childhood favourites.

I would like to thank the authors included in this book. I am also grateful to the staff at the National Portrait Gallery, especially my editor Susie Foster for her enthusiasm and patience. Also, Clare Gittings, Education Officer, Terence Pepper, Clare Freestone and Sarah Le Fort in the Gallery's Photographs Collection, Kate Eustace, Twentieth Century Curator, and the staff in the Exhibitions, Design, PR and Development departments.

On behalf of the National Portrait Gallery, I would like to thank all the lenders to the exhibition and I am grateful for the additional support from Elizabeth Booth, Sara Mills and Yasmin Keyani at Frederick Warne & Co., Elizabeth Stevens at Curtis Brown, Liz Whittingham and Amanda Conquy at the Roald Dahl Museum and Literature Centre, Wendy Kress at Dahl & Dahl, Adele Minchin and Elaine McQuade at Penguin and Alexandra MacLean at Chorion Intellectual Properties.

JULIA ECCLESHARE

Foreword

EVERYONE has stories to which, in childhood, they returned again and again, for enchantment or solace, amusement, or even from grim fascination. In part we are formed by the tales that are told us. Sometimes it's possible to look back and understand why this picture book seemed to have such a special meaning, why that novel was a comfort, how this book explained so much. Sometimes it remains a mystery.

The British have had so many fine writers for children. Explanations for this pre-eminence in the field range from the warping effects of our miserable and mercurial climate to the unenviable way in which so many of our offspring are raised. Clearly, part of this excellence in some kinds of writing for the young springs from that national quirk called the British sense of humour. But I suspect a good deal also stems from rebellion against that other characteristic for which we're supposedly noted – our hypocrisy.

For there's an honesty in children's literature that readers find first startling, then exhilarating. Picasso claimed that 'Art is a lie that tells the truth', and perhaps the most impressive thing about the books that have lasted is how much truth is in there somewhere, however it might be disguised.

Whatever the reason, the British certainly excel. Even the fact that so many of our writers are fêted all over the world in translation, and yet comparatively few children's books from abroad are well known here, cannot simply be explained away by our unarguable insular tendencies. There is something very special about the way authors raised here write for children.

How fitting, then, to put together this splendid array of authors to mark an extraordinary hundred years. And what is so cheering is that there's nothing in the least bit valedictory about this parade of faces. Nobody knows which names will last – or, in the case of many in this book, last even longer. But we can all be sure that writing for children today is as lively and assured as ever, still offering hours of pleasure, still provoking self-reflection and discussion, still opening whole worlds to the growing child.

ANNE FINE
Children's Laureate

Introduction
Beatrix Potter to Harry Potter

FROM one Potter to another, the twentieth century produced a gold mine of books for children. Authors and illustrators have enriched children's lives, offering imaginings, journeys, opportunities, reassurance and humour beyond the limits of their readers' daily existence. Their books have been handed down, linking the generations and serving as constant reminders of childhood experiences.

The lives of the creators of these old friends are as varied as they are fascinating. Why did they write for children? Some, like Henry Williamson, never intended to and are included here by adoption rather than intention. Others wished that they never had! Richmal Crompton regarded William as her 'Frankenstein monster'. Some, such as J.M. Barrie, Dodie Smith and Roald Dahl, wrote for adults also but have found far greater fame with their books for children. But there are many whose first commitment was to storytelling for children. Initially they wrote for a particular child, or children, but then wanted to share their stories with a wider audience. They were attracted by the situation of children, the 'condition' of childhood with its attendant qualities of innocence and the possibilities that such storytelling offered. Peter Rabbit first appeared in letters written by Beatrix Potter to Noel Moore; Hugh Lofting's stories about the good Doctor Dolittle of Puddleby were a way of communicating with his children when he was far away during the First World War; the Thomas the Tank Engine stories were written down by the Revd W.V. Awdry to make sure that he got the details right when he told them every night to his son Christopher.

Whatever the initial reason for writing, one thing is certain: there was nothing childlike or sentimental in the intentions of the authors. Children's writers were, and are, professionals. They wrote to entertain, yes, but also to earn a living. Beatrix Potter craved independence as an adult and only achieved it because of the money she made from her books. Similarly, Enid Blyton wrote to live, and as the producer of over 700 books no one could accuse her of not working at it. E. Nesbit records something of herself in *The Railway Children* (1906), where it is the mother's success with a story that pays for the buns for tea; it was Nesbit's own success with *The Story of the Treasure Seekers* (1899) and *The Wouldbegoods* (1901) that brought her family some comfort and financial security.

Contemporary writers are also professionals: they know their audience and their market, and they write for them. They have the advantage of being able to build on the long-lasting reputations of those who have gone before. Will they last? Who can say, but, as the twentieth century closed, one thing had changed little between one Potter and another. Harry Potter, now called 'the most famous child in history', has caused his author J.K. Rowling to take refuge from the celebrity status that surrounds her. Similarly, Beatrix Potter shunned the fame that success had brought and spent the latter part of her life repelling interviewers – unless they were from the United States – and refused to give permission for any biographer to write about her.

The lives of those writers whose stories became an essential part of childhood hold endless fascination for their readers. In writing this book, I hope to provide a moment of insight into the inspiration behind their work.

1900
–1920

The beginning of the twentieth century opened up new possibilities for children's writers. Characters such as Beatrix Potter's Peter Rabbit and J.M. Barrie's Peter Pan enchanted readers, providing an escape from the serious, moral tone of many Victorian books.

BEATRIX POTTER

1866–1943

THE elder child of wealthy parents, Beatrix Potter had a lonely childhood until she was nearly six, when her brother Bertram was born. She described her London home as 'my unloved birthplace', and certainly it provided little entertainment for a child. Potter's nursery had few toys and she learnt to read from Sir Walter Scott's 'Waverley' novels and the complete works of Maria Edgeworth, an early nineteenth-century moralising writer for children. The monotony of her life was broken only by a daily walk and by the pets she kept (including a series of rabbits).

However, every year the Potter family holidayed in the North: at first Scotland, later the Lake District. In both places Potter and her brother were free to explore their surroundings, and they began to make collections of all the plants, animals and insects they could find, which they then drew and painted. Potter's attention to detail and her blend of realism and fantasy is already evident in these drawings, in which the occasional dressed-up animal appears.

Until she was fifteen Potter was taught by governesses, who encouraged her to draw and developed her interest in nature. She once wrote 'Thank goodness, my education was neglected; I was never sent to school ... The reason I am glad I did not go to school – it would have rubbed off some of the originality (if I had not died of shyness or been killed with over pressure).' (Article for *The Horn Book*, 1929.)

After her 'formal' education was over, and with little else to fill her days, Potter spent many hours drawing and painting in the Natural History Museum, London. She became an accomplished scientist and spent over thirteen years developing a theory on the germination of fungus spores. When her work was rejected by the professionals, Potter turned her attention to her other favourite subject: her pets. She drew them dressed up in clothes for a series of Christmas

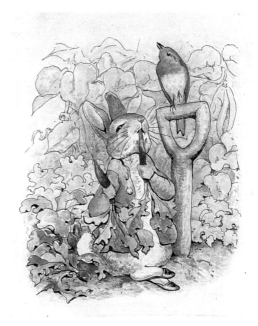

'First he ate some lettuces and some French beans;
and then he ate some radishes'
The Tale of Peter Rabbit by Beatrix Potter
Reproduced with kind permission of Frederick Warne & Co.

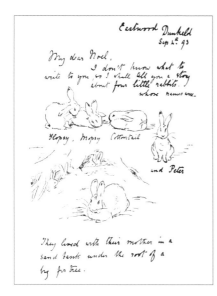

Letter from
Beatrix Potter to
Noel Moore,
4 September 1893
Reproduced with
kind permission
of Frederick
Warne & Co.

cards and then as a collection of pictures that accompanied Frederic Weatherly's verse in *A Happy Pair* (1890), her first published work.

In all the books that followed Potter was both the author and the illustrator. The first, *The Tale of Peter Rabbit* (1901), began as a story told in letters to Noel Moore, the five-year-old son of a former governess. Noel was recovering from a long illness and Potter's illustrated letters told him about her rabbit Peter. Rejected by the publisher Frederick Warne, Potter had the book privately printed in an edition of 250 copies with black-and-white illustrations. On seeing the finished book Warne agreed to publish a new edition with coloured illustrations. This appeared the next year. Later, there was even a Peter Rabbit soft toy that was sold in Harrods.

Warne was keen to have more stories, and in 1903 Potter followed *Peter Rabbit* with *The Tailor of Gloucester* and *The Tale of Squirrel Nutkin*. Squirrel Nutkin and such later characters as Jeremy Fisher and Hunca Munca had all first appeared in Potter's letters.

Although Potter had owned Hill Top Farm in Sawrey, Cumberland, since 1905 and it had featured in many of her illustrations, she never lived there. The success of her books enabled her to buy Castle Farm, also in Sawrey, in 1909. It was through buying this farm that she met the solicitor William Heelis, whom she married in 1913.

Potter now devoted herself to the Lake District, where this portrait is set. In a letter to a friend she wrote, 'I am "written out" for story books, and my eyes are too tired for painting; but I can still take great and useful pleasure in old oak – and drains – and old roofs – and damp walls – oh the repairs!' On her father's death she received a substantial inheritance and in 1923 bought a 2,000-acre farm, where she bred Herdwick sheep. She also worked tirelessly for the National Trust and bequeathed her farm and substantial land to it.

BEATRIX Potter's stories have been adapted for every medium. The ballet made for the film *Tales of Beatrix Potter* (1971) was performed on stage by the Royal Ballet Company in 1992, and has been in its repertoire ever since. Audiences love it but the dancers find the costumes bulky and hot! From 1992 to 1995 *The World of Peter Rabbit and Friends* ™, an animated series of specials for television and video, was broadcast every Christmas and Easter on the BBC and in fifty countries worldwide.

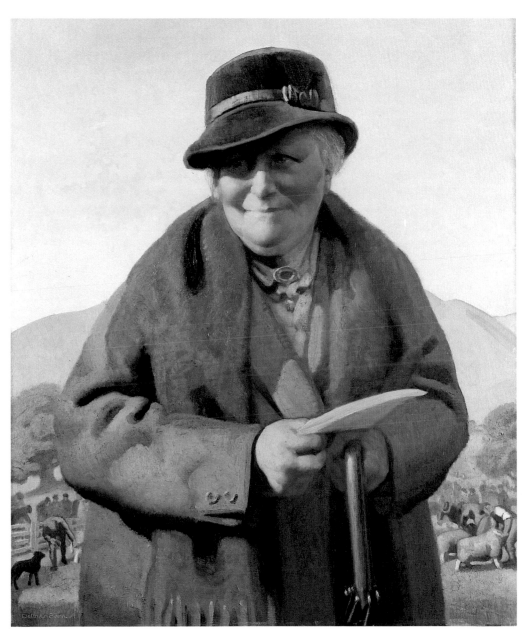

Beatrix Potter, 1866–1943
Delmar Banner, 1938
Oil on canvas, 749 x 622mm (29 $^1/_2$ x 24 $^1/_2$")
National Portrait Gallery (NPG 3635)

J.M. BARRIE

1860–1937

IN his play *Peter Pan*, about the boy who never would grow up, J.M. Barrie, who retained childlike characteristics throughout his own life, created an icon of childhood.

Born in the Scottish Lowlands, James Matthew Barrie was the ninth child of a weaver. When he was six his thirteen-year-old brother David died and Barrie found that he alone could comfort his mother for the loss of her favourite son. From then on Barrie remained intensely close to his mother and he wrote to her every day until she died when he was thirty-five.

Encouraged by his mother, Barrie went to Edinburgh University. He was uncomfortable in the company of other students, partly because he felt he did not fit in as he was only five foot three inches when fully grown and, despite a moustache, always looked boyish. He had no interest in girls and recorded with disdain in his diary that 'men can't get together without talking filth'. Barrie worked as a journalist and critic in Edinburgh and Nottingham before he moved to London and began to write. His third novel, *The Little Minister* (1891), made him a household name and he had several plays performed, including *Walker, London* (1892), whose leading lady, Mary Ansell, became his wife in 1894. The marriage, which was childless, was dissolved in 1909.

It was Barrie's meeting with Sylvia and Arthur Llewelyn Davies in 1897 that led to the creation of Peter Pan. Barrie adored Sylvia and soon became a close friend of the family, although his relationship with Arthur was always difficult. With no children of his own, Barrie played with the five Llewelyn Davies sons and fulfilled his childhood fantasies, seeing the boys with their healthy outdoor play at imaginary games as the perfect realisation of a boyhood he himself had not experienced. Both Arthur and Sylvia died young, and Barrie became the guardian of the Llewelyn Davies boys. It was a relationship fraught with tragedy: George, the eldest, was killed in the First World War in 1915 and his brother Michael drowned while at Oxford University in 1921.

Peter, the magical boy, first appeared in print in Barrie's adult novel *The Little White Bird* (1902). Set in Kensington Gardens, where Barrie met the Llewelyn Davies boys, it was partly based on a story that Barrie had told George about how his baby brother Peter could fly out of his pram like a bird. The story also had its origins in the death of Barrie's brother, who had remained forever a child in his mother's eyes. Barrie expanded on the idea for a play; the swashbuckling pirates and Indians drew on

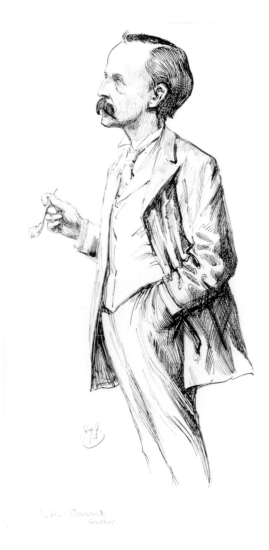

Sir J.M. (James Matthew) Barrie, 1860–1937
Harry Furniss, 1880s–1900s
Ink, 314 x 156mm (12 3/8 x 6 1/8")
National Portrait Gallery (NPG 3420)

his love of R.M. Ballantyne's *The Coral Island* (1858) and the games played during a holiday in the Lake District with the Llewelyn Davies family. Barrie invented the name Wendy from a different source – the lisping six-year-old Margaret Henley, who called Barrie 'my fwendy'. *Peter Pan; or, The Boy Who Would Not Grow Up* was initially thought to be impossible to stage both because of the large cast and the fact that the characters were required to 'fly'. However, from its first performance in London on 27 December 1904, it was an immediate success with both adults and children – a success that has continued ever since.

E. NESBIT

1858–1924

EDITH Nesbit was the youngest of six children. When she was three her father died and her mother took over the running of his agricultural college: absent fathers and capable mothers are recurrent in Nesbit's stories. Educated in France and Germany, Nesbit's memoir of her early years *Long Ago When I Was Young*, published posthumously in 1966, describes her childhood terrors associated with being away from home. She also records some happier times when the family lived in Kent enjoying a freer childhood, rather as her fictional family the Bastables enjoyed in her subsequent books.

When she was twenty-two Nesbit married Hubert Bland. She had three children and later adopted her husband's two illegitimate children. Bland was a founder-member of the socialist-leaning Fabian Society, which Nesbit also joined. She became an active, if not wholly committed, member although she did not express Fabian views in her children's stories.

Nesbit had begun writing as soon as she left school. From the beginning she wrote 'to keep the house going', and her output of poetry and novels for both adults and children was huge and largely indifferent until the publication of *The Story of the Treasure Seekers* in 1899. The first of three related titles, with *The Wouldbegoods* (1901) and *The New Treasure Seekers* (1904), *The Treasure Seekers* was immediately successful and brought Nesbit both notice and prosperity. This was her most productive period as a novelist. *Five Children and It* (1902), *The Phoenix and the Carpet* (1904) and *The Story of the Amulet* (1906), three stories each with its own engaging magical creature – the Psammead, the Phoenix and the Mouldiwarp – and *The Railway Children* (1906), which had begun as a serial in the *London Magazine* in 1904, were all published within the space of a few years.

Nesbit's success financed the move to a large house in the country where the family entertained extensively. She continued to write until 1913, although she never again achieved the same popularity, and it was not until after her death that she was recognised for her novels, which became classics of childhood.

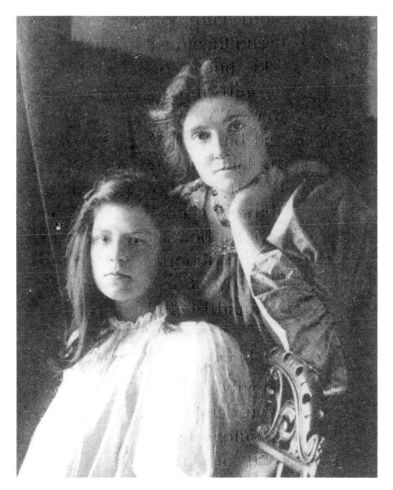

FIVE Children and It and *The Phoenix and the Carpet* were both successfully adapted for television, but it is *The Railway Children* that stands out as the lasting favourite of Nesbit's titles. The resourcefulness of the children in fighting to clear their father's name far outweighs the unlikely number of coincidences that make it possible. The 1970 film version launched Jenny Agutter's career as well as giving Bernard Cribbins a superb cameo role as Perks the Porter.

Edith Nesbit, 1858–1924, with one of her two daughters
James Russell & Sons, published in the *Bystander*, 12 April 1905
Half-tone reproduction of a lost photograph, 203 x 152mm (8 x 6")
National Portrait Gallery (NPG RN45718)

ANGELA BRAZIL

1869–1947

ANGELA Brazil (who insisted that her name should be pronounced to rhyme with dazzle) created the modern school story for girls. The daughter of a cotton mill manager, Brazil was brought up near Manchester and went to Manchester High School and then Ellerslie College, where she became head girl. Neither was the boarding school with its enclosed and intense societies that Brazil so longed for, but it was at school that she had the passionate romantic relationships with other girls that occur repeatedly throughout her books. Brazil studied art in London and travelled extensively in Europe. In 1911 she moved to Coventry to look after her brother and his medical practice, where she was later joined by her sister. All three siblings then lived together. None of them married.

Brazil was in her thirties when she wrote her first novel *A Terrible Tomboy* (1904). Finding she enjoyed the experience, she turned her hand to a school story *The Fortunes of Philippa* (1906), which drew on her mother's boarding-school days. The book was a considerable success and Brazil was commissioned by Blackie to write another school story. The result was *The Third Class at Miss Kaye's* (1908), which marked out the territory of the fifty and more titles she went on to write. Her 'works', as she called them, vary enormously in quality but all contain plenty of hockey and cricket and a great emphasis on friendship and the emotional complexities it creates, something she seemed to understand especially well. Above all, Brazil's books are peppered with idiosyncratic slang – phrases such as 'it's a blossomy idea' and 'a very jinky notion' – which she claimed to have overheard teenage girls using. Whether accurate or not, it was Brazil's use of slang that caused her books to be roundly condemned by two successive high mistresses of St Paul's Girls' School in London, who thought them unsuitable reading.

Although the school setting was old fashioned, Brazil kept up to date with the changing role of women, making the stories far removed from the Victorian model of many of her predecessors. Her characters were always emotionally and physically robust girls who participated in school life. Specifically, following the outbreak of the First World War, Brazil's characters reflected the patriotism of the era and the increasingly active role that girls were playing in all areas of society. It was a tradition that flourished, with Brazil's many followers creating school story worlds of their own in books such as Dorita Fairlie Bruce's (1885–1970) 'Dimsie' titles, and Elinor Brent-Dyer's (1894–1969) extensive 'Chalet School' series.

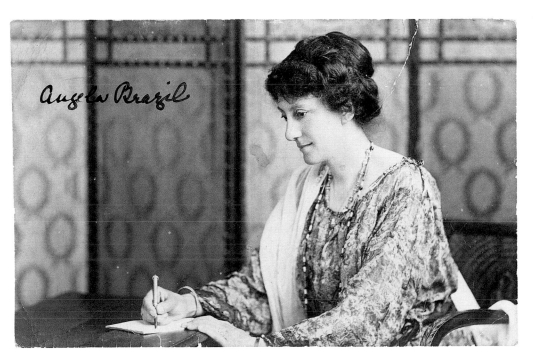

Angela Brazil, 1869–1947
Elliott & Fry, 1920
Matt bromide postcard, 89 x 137mm (3¹/₂ x 5³/₈")
National Portrait Gallery (NPG x19821)

FRANK RICHARDS

1876–1961

FRANK Richards is the most famous of the twenty or more pseudonyms of Charles Hamilton, whose prodigious output for a succession of magazines includes the creation of Greyfriars School and its notorious, overweight pupil Billy Bunter. Hamilton created over 100 fictional schools, as well as writing Wild West adventures, detective stories and romances.

Hamilton was born in Ealing, West London; his father, a journalist, died when he was seven. Despite writing so extensively about public-school life, Hamilton was evasive as to whether he had ever been to a public school and it is thought more likely that he was educated at a succession of day schools around Ealing. While still at school, Hamilton wrote prolifically and had some stories accepted in boys' magazines. On leaving school he became a freelance writer before joining the staff of *Pluck* in 1906 and it was there, under the pseudonym Martin Clifford, that Hamilton created his first school, St Jim's. Combined with another 'Martin Clifford' series about Tom Merry, which Hamilton wrote for *The Gem*, the stories of St Jim's continued to be published until the Second World War.

Only one year later, Hamilton, under the new pseudonym Frank Richards, wrote his first Greyfriars story for the newly launched magazine *The Magnet*. Frank Richards became Hamilton's favourite pseudonym, just as Greyfriars remained his favourite creation. Much later, Hamilton produced a succession of novels, starting with *Billy Bunter of Greyfriars School* (1947) and continuing through over thirty titles. Hamilton worked at great speed. Producing his two series, as well as writing stories for other papers, he was writing around 70,000 words a week. In 1915 he invented another school – Rookwood – under the pseudonym Owen Conquest. Soon after came Hamilton's one excursion into writing for girls, his Bessie Bunter series under the pseudonym Hilda Richards for *School Friend*. However, this was not as successful as his stories for boys and he was quickly dropped from *School Friend*, although the series was continued by other writers.

Despite his output, Hamilton wrote only during the working week and enjoyed lengthy holidays travelling in Europe and gambling in Nice and Monte Carlo. In 1940, while still at the height of production, Hamilton was roundly attacked by George Orwell in an article in *Horizon* both for his lack of literary merit and for giving his working-class readers a distorted view of the world. Hamilton replied briskly, claiming that he preferred to inject warmth and humour into his young readers' lives rather than limit their vision to reality.

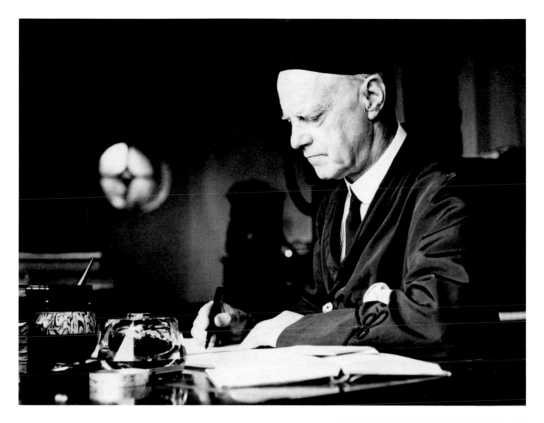

Frank Richards (Charles Hamilton), 1876–1961
John Pratt, May 1946
Bromide print, 149 x 199mm (5$\frac{7}{8}$ x 7$\frac{7}{8}$")
Courtesy of Mary Cadogan

BILLY Bunter 'the Fat Owl of the Remove', with his ridiculous exploits wholly propelled by greed, entertained readers for weeks on end. Bunter was the butt of everyone's jokes, far removed from the successful sporting heroes of traditional school stories. From 1952 to 1962, *Billy Bunter of Greyfriars School* ran as a television series in half-hour episodes that kept 'the Fat Owl of the Remove' in the public eye long after the heyday of the books themselves. The role of Billy Bunter was played by an adult, Gerald Campion.

KENNETH GRAHAME

1859–1932

KENNETH Grahame was born in Edinburgh. His mother died when he was five and his father, a lawyer, was unable to cope with his young family and sent them to live with their maternal grandmother in Cookham Dene, Berkshire. Her house, set in a large garden by the River Thames, provided the Grahame children with a wonderful playground and also supplied the background for *The Wind in the Willows* (1908).

Grahame's plans to go to Oxford University were thwarted by his uncle, who was now acting as his guardian, and Grahame went to work for the Bank of England. For all its disadvantages, and Grahame's disappointment at not going to Oxford, life at the Bank was leisurely and it gave him time to write. He first made his name with *The Golden Age* (1895) and *Dream Days* (1898). Although exceptional in capturing the child's view of relationships, the books were intended for adults and were read by them.

The inspiration for most of *The Wind in the Willows* was very different. Grahame first told his river bank stories to his four-year-old son, Alastair. Grahame had married Elspeth Thomson in 1899; tragically, their only son was born blind in one eye and with a severe squint in the other, imperfections that both parents found hard to accept. Alastair was given to great rages and it was to soothe him that Grahame first invented Ratty, Mole, Badger and, above all, Toad, whose excesses of behaviour matched Alastair's. The stories continued in letters sent to Alastair while he was on holiday away from his parents in 1907. Now living back in Cookham Dene, Grahame collected his stories creating a cast of animal characters imbued with all too human characteristics.

At first Grahame found it hard to find a publisher for *The Wind in the Willows* as it was thought too fantastic, and indeed many of the critics hated it – *The Times* claimed that 'grown-up readers will find it monstrous and elusive'. Nevertheless, the book was an immediate success with its readers. Six months after publication there had already been four editions and it has remained a best seller ever since.

Grahame became increasingly reclusive after the publication of *The Wind in the Willows*, especially following the tragic death – almost certainly suicide – of Alastair in May 1920. He lived in Italy for several years before settling in Pangbourne, Berkshire, the stretch of river that became the location for E.H. (Ernest Howard) Shepard's (1879–1976) celebrated illustrations to later editions of *The Wind in the Willows*.

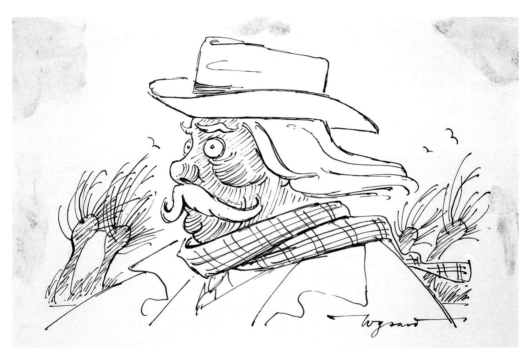

Kenneth Grahame, 1859–1932
Anthony Wysard
Pen and ink with bodycolour,
paper size 284 x 222mm (11$^{1}/_{8}$ x 8$^{5}/_{8}$")
National Portrait Gallery (NPG D275)

TOAD of Toad Hall, A.A. Milne's hugely successful stage adaptation of *The Wind in the Willows*, focused the story far more closely on the adventures of the animals, cutting out most of Grahame's romantic fantasy. After many years as a play it was was adapted as a black-and-white film in 1946, and again, as a Walt Disney colour animation, in 1949. Classic television versions were made in 1983 and 1996 and the Royal Shakespeare Company created a new stage production for its Christmas show in 1986. Wysard's caricature of a wind-swept Grahame amongst the willow trees encapsulates his famous book title.

FRANCES HODGSON BURNETT

1849 – 1924

FRANCES Hodgson Burnett was a successful adult novelist before she started to write for children, but it is for her three children's books – *Little Lord Fauntleroy* (1886), *A Little Princess* (1905) and, most of all, *The Secret Garden* (1911) – that she is best remembered. She was brought up in Manchester and her father died when she was three, leaving his ironmongery business to be run by his wife. When Frances was in her teens, her mother sold the business and emigrated to the United States with her family.

Frances, who had been an eager teller of romantic stories to her school friends, began writing in order to make money. Within two years she was having some success and her stories were published in prestigious magazines, such as *Scribner's*. By the time she was twenty-three, Frances had made enough money to travel to England for a prolonged visit before returning to the United States and marriage to a doctor, Swan Burnett, with whom she had two sons. After her marriage she continued to write and her first success on both sides of the Atlantic was with an adult novel *That Lass o'Lowrie's* (1877). She moved with her family to Washington, DC, where she wrote several more novels, including *Little Lord Fauntleroy* . The character of the almost-too-good-to-be-true boy first appeared in a magazine serial and its success as a novel was instantaneous: it was one of the year's best sellers, alongside Rider Haggard's *King Solomon's Mines* and Tolstoy's *War and Peace.*

Burnett used the money from *Fauntleroy* to buy a house in Kent, so beginning a pattern of transatlantic living that she retained for the rest of her life. Divorced from Swan Burnett, she remarried in England in 1900 but her second marriage failed after only a year. The success of *Fauntleroy* encouraged her to adapt *Sara Crewe* (1888), her earlier title for children, as a play, which she renamed *A Little Princess*, the title she also used when she came to rewrite the novel in 1905. Several further stories for children followed, some of which had originally been told to her sons, before she wrote *The Secret Garden*. In Mary and Colin, she created two complex and interesting characters, demonstrating a greater sophistication in her writing than many of her predecessors. A less sentimental story than either *Little Lord Fauntleroy* or *A Little Princess, The Secret Garden* is redolent of Yorkshire, although Burnett wrote most of it in her garden in Kent. It is the countryside and blossoming nature that have the power to cure Mary of her crossness and Colin of his disability, and this reflects Burnett's own yearning for both family and home.

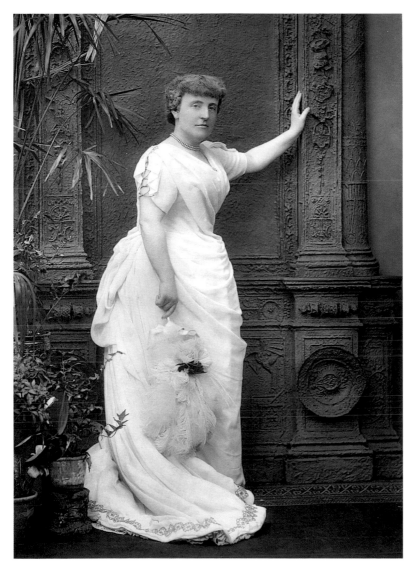

FROM as early as 1914, when the first black-and-white silent film of *Little Lord Fauntleroy* was released, Frances Hodgson Burnett's novels have been adapted countless times. *The Secret Garden* was first produced as a film in 1919 and the many subsequent versions include the memorable 1993 film with its fantastical garden full of magical flowers. A musical version was staged by the Royal Shakespeare Company in 2001.

Frances Hodgson Burnett, 1849–1924
Herbert Rose Barraud, 1888
Sepia carbon print, 245 x 175mm (9⁵/8 x 6⁷/8")
National Portrait Gallery (NPG x5179)

HUGH LOFTING

1886–1947

AS befits the creator of Doctor Dolittle, Hugh Lofting owned a menagerie of animals when he was a child. He even had a miniature zoo, which he kept in his mother's linen cupboard.

After his education in England, Lofting moved to the United States where he trained as a civil engineer. He worked as a surveyor in Canada before brief spells on the railways in Africa and South America. He then returned to New York where he abandoned engineering and began to write. During the First World War Lofting worked for the British Ministry of Information in New York and later served with the Irish Guards in Flanders. It was in his letters to his two children during the war that Lofting started the Doctor Dolittle stories. Their origins lay in his horror at the terrible treatment of the horses used in battle: he imagined a casualty station where they were treated by vets who could understand their language. Rather than reflect the grim reality of what he was witnessing, Lofting wrote the stories to make his children laugh.

The Story of Doctor Dolittle (1920) was first published in the United States and then two years later in Britain (a pattern that was followed with the subsequent titles). The book was an immediate success and the doctor and his houseful of engaging and original talking animals – Dab-Dab the duck, Jip the dog and Gub-Gub the pig – as well as the more outlandish creations, most notably the Pushmi-Pullyu, were soon firmly established as favourites on both sides of the Atlantic. Thought of as charmingly naive, especially because of Lofting's own simple illustrations, the books were well liked not least for the benign creation of Doctor Dolittle himself, who remains unfailingly patient and generous throughout all his adventures.

Eleven sequels followed, three of them posthumously finished by a relative. Lofting himself had grown tired of Dolittle some time before and had planned to abandon him on the moon, to which he had been transported by a giant moth, in *Doctor Dolittle in the Moon.* This was published in Britain in 1929 as a way of ending the series. However, there was considerable demand for yet more stories and Lofting obliged, drawing on his extensive travel as an engineer to supply exotic backgrounds.

Illustration from
Doctor Dolittle
By Hugh Lofting
Private Collection

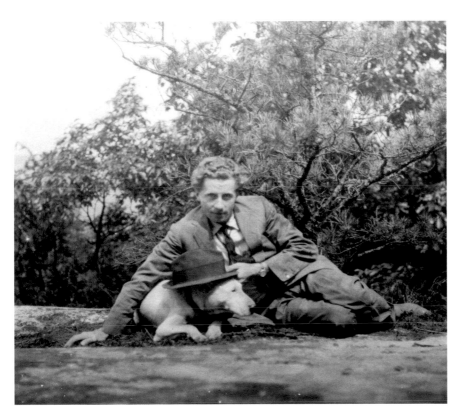

REX Harrison starred as the good doctor in the 1967 film adaptation of *Doctor Dolittle*. More recently, Eddie Murphy has taken the lead role in the Hollywood films *Doctor Dolittle* (1998) and *Doctor Dolittle 2* (2001). The stage musical, which opened in London in 1998, includes a love affair for Dolittle, although this is not something Lofting ever touched on in the books.

Hugh Lofting,
1886–1947
Modern print, 508 x 406mm (20 x 16")
Private Collection

It is Dolittle's (or Lofting's) excursions abroad and, above all, his imperialist attitudes to the 'natives' who lived there that have tarnished Lofting's reputation in more politically sensitive times. Passages such as that in which Prince Bumpo attempts to turn himself white, and asks Dolittle to help, have led to the condemnation of Lofting as a racist; but it must be borne in mind that he was merely reflecting commonly held views at the time of writing. Given the character of Dolittle and his courteous interactions with animals and humans alike, it seems unlikely that Lofting ever meant to cause offence.

MARY TOURTEL

1874–1948

TRAINED at the Canterbury School of Art, Mary Tourtel had written and illustrated many children's books that revealed her particular talent for drawing animals before she hit on Rupert Bear, her comic-strip hero. Married to a night editor on the *Daily Express*, Tourtel was asked to produce a comic strip for the paper to rival Charles Folkard's *Teddy Tail*, which had proved highly successful for the *Daily Mail* since 1915. Tourtel had several attempts at different animal characters before she created Rupert and his friends Bill Badger, Algy Pug, Edward Trunk and Podgy Pig in 1920.

The animals were a success from the beginning. In Rupert, Tourtel created an innocent and trusting character whose adventures had an element of fantasy, magic and wish fulfilment that appealed to both adults and children. In each story Rupert and his friends take off on adventures but always return to the security of domesticity. The text was in the sophisticated medium of quatrain verse, while the uncluttered illustrations had an eye-catching simplicity.

Tourtel's own passion was for flying. As early as 1919 she had flown a Handley-Page from London to Belgium in a record-breaking trip, and she once wrote that she liked 'seeing the land as birds saw it'. She was keen for Rupert to enjoy flying, too: his experiences included flights in an airship as well as being made airborne by magic shoes and his laundry basket.

Tourtel wrote and drew the Rupert strips for fifteen years until 1935. Such was their popularity that they were also published in book form, sometimes with the addition of new stories. By 1930 there was a Rupert League, one of the earliest fan clubs for a book character. In 1935 Tourtel had to abandon her work on Rupert as her eyesight was failing and the strip was taken over by Alfred Bestall, who kept the basic principles of Rupert but gave the illustrations some fresh, new colour and a rather more worldly air. Bestall wrote and illustrated the Rupert series for almost forty more years. From 1974 on, Rupert was drawn by a number of artists but his popularity has endured remarkably despite the changes of illustrator.

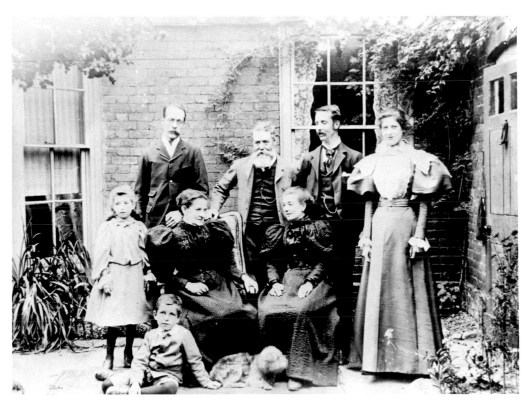

Mary Tourtel, 1874–1948 (far right, standing)
Modern print, 180 x 242mm (7¹/8 x 9¹/2")
By kind permission of Chris and Muriel Laming

Searching for security

CHILDHOOD is traditionally a time of security and nurture, a tradition that is largely maintained in children's fiction, where exploration and its attendant risks are generally taken against a background of security and love. Children's fiction is often set in imaginary worlds, thus allowing for new opportunities and freedoms. Surprisingly, these worlds and their make-believe landscapes, which in turn have shaped the imaginations of generations of children, have often been invented by writers whose own childhoods were far from happy or secure. As this book reveals, a remarkable number of the great children's writers of the twentieth century suffered from an unhappy or disrupted childhood – some lost one or both parents, others were separated from them.

It is perhaps to make up for this loss, and with it the security in which to experience childhood freely, that they later created idylls. For their creators as much as for the readers who enter them, these fantasy worlds offer a chance to be loved wholeheartedly and to revel in 'play' – a vital ingredient of childhood.

Beatrix Potter's childhood had no tragedy in it but she was a lonely and isolated child who described her home as 'my unloved birthplace'. The Lake District landscapes in which she set many of her stories reflect the long and happy childhood holidays she spent there; a time when she was free to roam and to observe the countryside that so inspired her.

The Never Never Land, where Peter Pan can live without ever growing up, was created by J. M. Barrie after a childhood in which his own emotional development was stunted following the death of his thirteen-year-old brother when he was six. Barrie became the main support for his mother, exchanging letters with her every day for the rest of her life. This, combined with his uneasiness in adult company, may well have played a part in his nostalgia for the perfect childhood of his imagination and his continuing search for the

delights of make-believe. Similarly, the emotional warmth and freedom of the river bank in *The Wind in the Willows* (1908) is in marked contrast with Kenneth Grahame's own childhood. Ratty, Mole and Toad splash happily all day long, ending up companionably in Mole End or Badger's underground den, evoking a comfortable ease with home and the nurture it can provide. For Grahame himself, there was no assured home. After the death of his mother, when he was five, he and his siblings were sent to live with relatives. Grahame lacked the specific love of a mother and the security of a family home of his own.

An absence of a secure family life was also the experience of many others. E. Nesbit, Frances Hodgson Burnett, Dodie Smith, C.S. Lewis, J.R.R. Tolkien and Kathleen Hale all lost a parent when young. Nesbit's, Burnett's and Hale's mothers kept their husband's businesses going as far as possible, providing their daughters with the role model of a robust woman coping alone but also leaving them with a sense of insecurity. Frances Hodgson Burnett was uprooted from home in her teens, when the family moved to the United States, leaving her with a deep-seated nostalgia for England. In *The Secret Garden* (1911) she returns to England and invests the countryside and especially the secret garden within it with magical properties; it is here that Mary grows emotionally and Colin physically.

Perhaps to ease the domestic situation, E. Nesbit and Kathleen Hale were both sent away to school. The imposed isolation caused each later to create warm and loving images of family life in compensation. Nesbit's cheerful Bastables and their adventures in *The Story of the Treasure Seekers* (1899) and *The Wouldbegoods* (1901) recreate the brief periods of her childhood when her family was settled. Written just before and during during the Second World War, Hale's first stories about Orlando, the Marmalade Cat, with their emphasis on family love, were told partly to create the united family that she never had and partly to keep alive the idea of family for the many children whose own families had been broken up by the war, especially the evacuee children.

Nina Bawden was herself an evacuated child and the profound experience of separation is reflected in *Carrie's War* (1973). Although not expressed as an idealised yearning for the warmth of family but as a realistic story of childhood survival, something of the same sense of loss is felt in Carrie's and her brother's search to replace the affection of the absent parents.

Post-war writers are less likely to have been separated from their parents, but a desire to preserve childhood or to record the pangs of its passing remains a constant theme. Philippa Pearce wrote *Tom's Midnight Garden* (1958), set in her own childhood home, when she imagined the house and garden might be under threat from developers. Its story of friendship across time preserves both the place and the magic of childhood, making it secure in perpetuity.

1920s
& 1930s

The spirit of freedom was celebrated in the books of the inter-war period. Feisty schoolgirls and rebellious boys provided intelligent and independent role models for a new generation of readers.

A.A. MILNE
1882–1956

A.A. (Alan Alexander) Milne was the third and youngest son of the headmaster of a small preparatory school in London. A gifted mathematician, Milne won a scholarship to Westminster School when he was only eleven. At Cambridge, where he studied mathematics, Milne wrote verse and humorous prose and achieved his ambition to edit *Granta*, the university magazine. After Cambridge he published work in several journals and magazines before becoming a regular contributor to *Punch*. At twenty-four he became the magazine's assistant editor, a job he retained until 1914 when he joined the Royal Warwickshire Regiment on the outbreak of war. In 1913 Milne had married Dorothy de Selincourt because, he claimed, 'she laughed at my jokes'.

During the war, encouraged by his wife who thought it would provide some escape from its horror, Milne wrote a play for his regiment. However, its fairytale structure seemed more suited to children so Milne refashioned it as a children's book and it was published in 1917 as *Once Upon a Time*. Milne did not immediately write another children's book; instead he made a reputation for himself writing adult plays and novels and continued to write for *Punch*. His plays, in particular, were extremely successful, including *Make-Believe* (1918) and *The Man in the Bowler Hat* (1924).

The inspiration for Milne's four classic children's books – all of which appeared between 1924 and 1928 – came from his only child, Christopher Robin (b.1920), and the nursery world of his nanny and his soft toys, Pooh Bear, Piglet and Eeyore. Ironically, since Milne was not an orthodox believer, 'Vespers', his first verse for children, was inspired by the sight of Christopher Robin being taught to say his prayers by his nanny: 'Hush, hush, whisper who dares, Christopher Robin is saying his prayers'. Milne gave the verse to his wife saying she could keep any money it brought in. She sent it to *Vanity Fair* in New York who paid $50 and published it in January 1923. Much later, Milne said this was one of the most expensive presents he had ever given. In his book *The Enchanted Places* (1974) Christopher Robin described 'Vespers' as 'the one [work] that has brought me over the years more toe-curling, fist-clenching, lip-biting embarrassment than any other'.

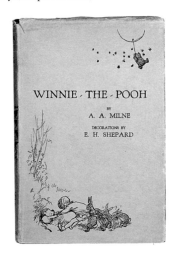

First edition of *Winnie-the-Pooh*
By A.A. Milne with illustrations
by E.H. Shepard (Methuen, 1926)
Teddy Bear Museum

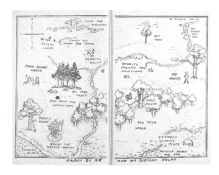

In that same year Milne wrote his first collection of nursery verses, which he described as 'a curious collection; some *for* children, some *about* children, some by, with or from children'. They were published as *When We Were Very Young* (1924), with illustrations by E.H. Shepard, a friend and colleague of Milne's from *Punch*. The book was an immediate runaway success in both Britain and the United States, and Milne began his stories about Christopher Robin, his soft toys and their adventures in the countryside around Cotchford Farm, the Milnes' country home in East Sussex. *Winnie-the-Pooh* (1926) and its sequel *The House at Pooh Corner* (1928), were also illustrated by Shepard, as was Milne's second collection of verses for the same audience *Now We Are Six* (1927).

Then, apparently bored with writing for children, Milne wrote nothing more for them except a few plays, including his dramatisation of Kenneth Grahame's *The Wind in the Willows* as *Toad of Toad Hall*, which was first performed in 1929.

Christopher Robin, the small boy about whom but not necessarily *for* whom the stories were written, remembered little about hearing them, although he could recall one occasion when he was the first audience:

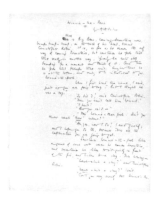

Map of the 'Hundred Acre Wood'
By E.H. Shepard
Endpaper from
Winnie-the-Pooh
(Methuen, 1926)
Teddy Bear Museum

Winnie-the-Pooh
manuscript
A.A. Milne, 1926
Paper,
220 x 180mm
(8 5/8 x 7 1/8")
Trinity College
Library

My mother and I were in the drawing room at Cotchford. The door opened and my father came in. 'Have you finished it?' 'I have.' 'May we hear it?' My father settled himself in his chair. 'Well,' he said, 'we've had a story about the snow, and one about the rain, and one about the mist. So I thought we ought to have one about the wind. And here it is. It's called:

"IN WHICH PIGLET DOES A VERY GRAND THING."
Half way between Pooh's house and Piglet's house was a Thoughtful Spot ...'
My mother and I, side by side on the sofa, settled ourselves comfortably, happily, excitedly, to listen.

(Christopher Milne, *The Enchanted Places*, 1974)

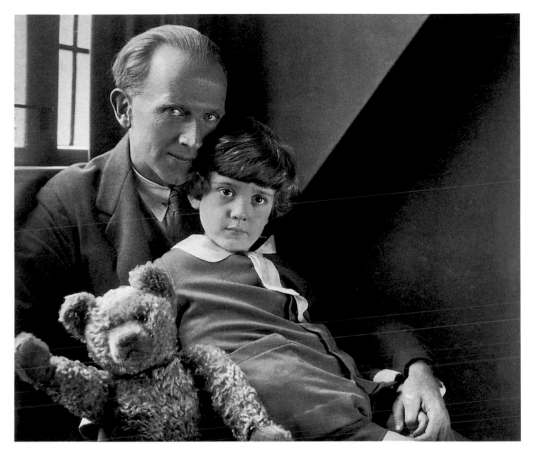

A.A. (Alan Alexander) Milne, 1882–1956, with
Christopher Robin Milne, 1920–96, and Pooh Bear
Howard Coster, 1926
Sepia matt print, 219 x 257mm (8⅝ x 10⅛")
National Portrait Gallery (NPG P715)

LIKE Beatrix Potter, Milne was eager for his books to be adapted for film,
dramatisation and broadcast – or in any other way (Ashtead Potters produced
Winnie-the-Pooh china in their years of production between 1926 and 1936).
In his last letter to *The Times* in April 1954 Milne condemned publishers for trying
to take a cut of the rights to these adaptations. The first Walt Disney adaptation
of *Winnie-the-Pooh* appeared in 1966 and, although it was disliked by E.H. Shepard's
admirers, it brought a new audience to Pooh without detracting from the sales of
the original books. Disney have continued to promote Pooh Bear through film and
merchandising, giving him a new identity that is instantly recognisable throughout
the world. In the 1990s Alan Bennett's reading of the Pooh stories for BBC
Audio delighted a more sophisticated audience, appealing to listeners of all ages.

RICHMAL CROMPTON
1890–1969

THE daughter of a clergyman, Richmal Crompton was considered a delicate child. Confined indoors she read and wrote, producing her own magazine 'The Rainbow'. 'Its circulation was confined to two, I used to read it to my small brother and my beloved rag doll,' she confessed. When she was thought to be strong enough Crompton was sent to boarding school, which she loved, and from there went to Royal Holloway College, London.

Although she became a very popular classics teacher, Crompton's ambition was to write for adults. Her short story about William Brown, an untidy, independent minded eleven-year-old who caused havoc wherever he went, first appeared as 'Rice Mould', a story for adults published in *Home Magazine* in February 1919. Crompton had tried writing about a boy character before, but her 'Thomas' was comparatively ordinary and it was only when she created the robust William, some of whose characteristics and exploits were based on memories of her brother Jack and from observations of her nephew, that she found success. She tried some female characters, girls who were feisty like William – as with Veronica in *Kathleen and I, and, of course, Veronica* (1926) – but they never had the vitality of William and remained merely cute and pert.

The short story was quickly followed by more about William with *Just William* and *More William* both appearing in 1922. Crompton juggled teaching and writing and produced *William Again* just one year later, but keeping the two careers going was a struggle. In 1923 she contracted polio, which left her with a paralysed right leg; teaching was no longer possible, so Crompton concentrated on William. She initially thought of William as her 'pot boiler', but later referred to him as her 'Frankenstein monster', because there was such a demand for William books that she was unable to give him up. She wrote one or two titles each year for the next twenty years. Her output slowed somewhat after the Second World War, although she continued to write, adding some slightly more contemporary references but keeping William himself as an unchanging eleven-year-old – even in the 1960s.

Crompton also wrote over forty adult books, but none of these ever achieved the reputation of her William stories. Although she had no children of her own she was very close to her nephews and nieces and was also a much-loved teacher, remaining in touch with many of her pupils.

Richmal Crompton, 1890–1969
Unknown photographer, c.1953
Bromide print, 152 x 205mm (6 x 8 1/8")
Private Collection

CROMPTON'S willingness to write so much about William is surprising in that, on the whole, the books do not reflect her own views or opinions. William's anarchic view of the world and his laziness about school work are in direct contrast with Crompton's own. More significantly, Crompton was a supporter of the Women's Suffrage Movement and yet strong-minded women are strangely under-represented in her books – except, of course, for little Violet Elizabeth Bott, whose threat to 'thcream and thcream til I'm thick' is one of the few things to subdue William and his Outlaws.

HENRY WILLIAMSON

1895–1977

TARKA the Otter, the book that brought Henry Williamson such fame, was not written for children. Like many other animal stories, it is categorised more by the interests than by the age of its readers. Originally published in 1927 as an adult book, it was immediately applauded and won the Hawthornden Prize the following year. It was published by Penguin in 1937 and adopted as a children's book in 1941, when it appeared as one of the first Puffins, Penguin's new children's list. Puffin's editor Eleanor Graham championed the book for young readers on the grounds that its otter-level view of the countryside was particularly suited to children as it more closely matched their view of the world.

Williamson's story was a true one: it was written from close observation of a real event. After the First World War, Williamson had gone to live in the tranquillity of North Devon. On finding a young otter cub whose mother had been shot by a farmer, he reared it by hand. The two became close companions until the otter's paw was caught in a gin-trap and, on release, it fled in terror from human contact. Williamson's search for the otter through the countryside is recorded in minute detail, bringing the rivers, with their vegetation and animal inhabitants, into sharp relief. He claimed to have rewritten the story seventeen times in order to get the detail right and it is that sharply recorded accuracy which accounts for much of the book's success.

The book was praised by writers on the countryside such as Thomas Hardy and, more recently, Ted Hughes, but the first edition was dedicated to the local Master of the Hunt – a dedication that now looks surprisingly contradictory given that the story is devoted to celebrating the life of an endangered creature.

Williamson was a powerful writer and wrote many other novels that recorded life in the country as well as *Tarka*. He had perfect recall, which enabled him to describe events in great detail. However, he had a difficult and obsessive temperament that caused him to quarrel with many and led to a misplaced sympathy for Hitler during the Second World War.

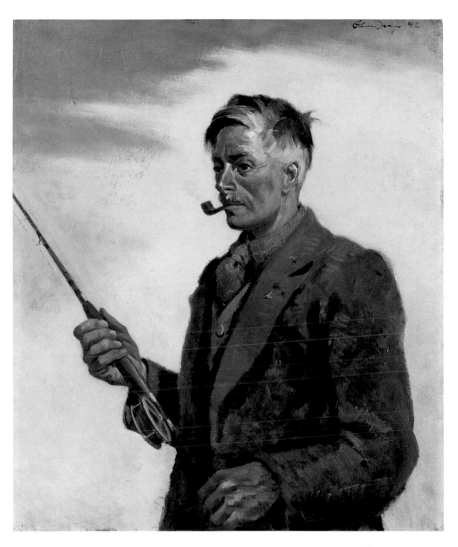

Henry Williamson, 1895–1977
Edward Seago, 1942
Oil on canvas, 763 x 635mm (30 x 25 ")
National Portrait Gallery (NPG 5713)

BY a strange coincidence, the filming of the scene in *Tarka the Otter* in which the otter dies took place on the same day as Williamson's own death in 1977. Williamson had originally worked on the film in the mid-1970s, but his deteriorating health had made it impossible for him to continue and the subsequent film was made without his knowledge. It was released in 1979 and featured Peter Ustinov as the narrator.

ARTHUR RANSOME
1884–1967

UNTIL his father's death when he was thirteen, Arthur Ransome's childhood holidays were spent in the Lake District. Although it provides the background to only five of his twelve novels for children, it is the landscape for which he is best remembered. Ransome left school at seventeen and went briefly to Leeds University to study chemistry. He then moved to London where he worked in publishing until he boldly gave up regular work in favour of writing, while not yet twenty. For a couple of years he worked as a freelance writer, during which time he wrote two collections of stories for children, *Highways and Byways in Fairyland* (1906) and *The Imp and the Elf and the Ogre* (1910).

Ransome married in 1909 and it was perhaps to escape from the failure of his marriage that in 1913 he went to live in Russia where he covered the events leading up to the Russian Revolution of 1917 for the British newspapers. He remained in Russia during the Revolution and his work brought him into close contact with both Lenin and Trotsky. Ransome continued his work as a foreign correspondent for the *Manchester Guardian*, moving from the Soviet Union to Egypt and then China. He returned to England in 1930 accompanied by Trotsky's secretary, who had become his second wife in 1924.

In 1929 Ransome left the staff of the *Manchester Guardian* to become once again a full-time writer. This time he was more successful. He had already written a collection of folk tales for children called *Old Peter's Russian Tales* (1916), while for adults he had published several books, including *Racundra's First Cruise* (1923), which, helped by maps, charts and diagrams, was the autobiographical story of his own sailing experiences in the Baltic. Drawing on memories of his childhood combined with his more recent experiences of sailing, Ransome wrote *Swallows and Amazons* (1930). This, the first of his children's novels, created an idyllic playground in which the children had to behave responsibly towards each other and the environment in order to get the best out of their situation.

Swallows and Amazons was well received from the start, both in Britain and the United States, and his sixth book, *Pigeon Post* (1936), won the Carnegie Medal. Ransome's holiday adventures with their convincing characters and plausible dramas entertained children with visions of a responsible freedom. Their success created an appetite for stories of this kind that lasted until the 1960s.

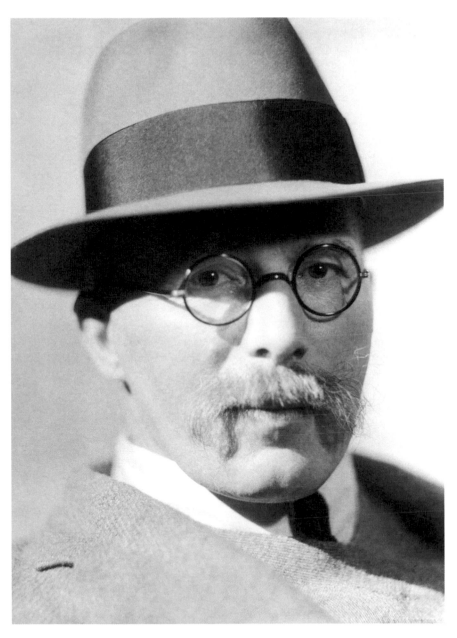

Arthur Ransome, 1884–1967
Howard Coster, 1932
Modern print from an original negative,
493 x 366mm (19 3/8 x 14 3/8 ")
National Portrait Gallery (NPG x12267)

P.L. TRAVERS

1906 – 96

'I have always said that I don't think that I write for children specially. After all, my early writing was mostly poetry and I imagine *Mary Poppins* stems from that.'

P.L. Travers never wanted to be thought of as a writer only for children and with good reason, since *Mary Poppins* (1934), despite its nursery setting and its magical happenings, is a tart story that does not celebrate children or childhood. In the book (as opposed to the well-known Walt Disney film of 1964) the eponymous nanny is an acerbic creature who introduces her charges to magic – and then denies that it has existed. She has none of the usual warm, lovable characteristics of a nanny. In fact, she is quite alarmingly harsh in her treatment of the young Banks children and her manner is abrupt and verging on the disagreeable. This was deliberate on Travers's part, which is why she so cordially disliked the film version for its sugary misrepresentation of what she had written: a dislike that caused her to block the production of a stage musical in similar vein.

Pamela Lyndon Travers, whose original career was as an actress and dancer, was born in Queensland, Australia, but came to Britain when she was seventeen. She made a small reputation as a poet and journalist before she wrote *Mary Poppins* – her first book. The story was written when she was recovering from an illness; her initial audience was two young children that she knew. The success of *Mary Poppins* was such that Travers quickly wrote two sequels. The third title, *Mary Poppins Opens the Door* (published in the United States, 1943, and Britain, 1944), was intended to be the last, and in it Mary Poppins leaves the Banks family for the very last time. But popular demand prevailed, even before the film appeared, and Travers wrote *Mary Poppins in the Park* in 1952. She returned to Mary Poppins thirty years later with *Mary Poppins in Cherry Tree Lane* (1982) and wrote about her for the very last time in *Mary Poppins and the House Next Door* (1989).

Travers wrote novels for adults and, despite not liking to be thought of as a children's writer, she also wrote other books for children, although they never had the success of *Mary Poppins*. *I Go by Sea, I Go by Land* (1941) is an entirely non-magical story of two children's evacuation to the United States during the Second World War, while *The Fox at the Manger* (1962) and *Friend Monkey* (1972) are both a blend of magic and mythology.

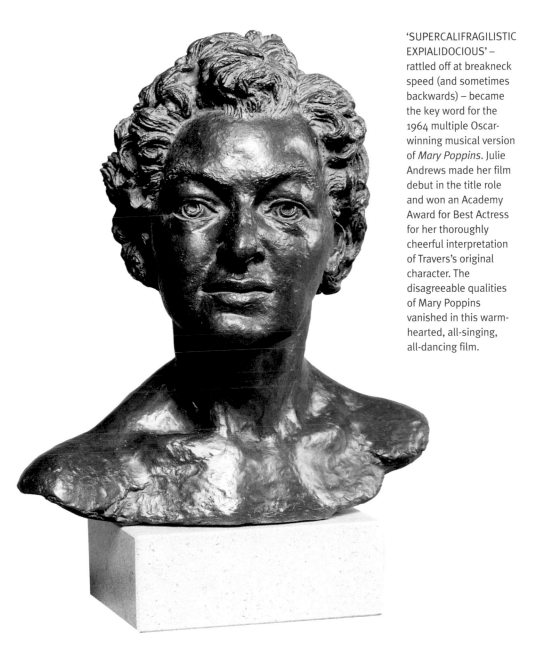

'SUPERCALIFRAGILISTIC EXPIALIDOCIOUS' – rattled off at breakneck speed (and sometimes backwards) – became the key word for the 1964 multiple Oscar-winning musical version of *Mary Poppins*. Julie Andrews made her film debut in the title role and won an Academy Award for Best Actress for her thoroughly cheerful interpretation of Travers's original character. The disagreeable qualities of Mary Poppins vanished in this warm-hearted, all-singing, all-dancing film.

P.L. (Pamela Lyndon) Travers, 1906–96
Gertrude Hermes, 1940
Bronze, 381mm (15") high
National Portrait Gallery (NPG 5888)

CAPTAIN W.E. JOHNS

1893–1968

THE background to the Biggles stories can be found in Captain W.E. (William Earle) Johns's own life. Johns left school at fourteen. His original ambition was to join the army but instead he was articled to a surveyor and became a sanitary inspector in Norfolk. The outbreak of the First World War brought him the opportunity to join up and he served in the Machine Gun Corps, seeing action in Gallipoli. Developing a love of flying, which was then in its infancy, Johns transferred to the Royal Flying Corps (later the Royal Air Force) in 1917 and took part in bombing raids on Germany. He was shot down over Mannheim, captured and, although he escaped, was recaptured and spent the rest of the war in a prisoner-of-war camp. Johns remained with the RAF as a Flying Officer until 1927, serving in India and Iraq. A reservist with the rank of Captain, but too old to take an active part in the Second World War, Johns continued to work as a lecturer for the Ministry of Defence.

Biggles, or James G. Bigglesworth as he is properly called, first appeared in 1932 in a story by Johns called 'The White Fokker'. Published in *Popular Flying*, the magazine that Johns founded and edited, it launched the career of the teenage flying hero. The Biggles stories were popular with readers and Johns collected several together in such early books as *The Camels Are Coming* (1932) and *Biggles of the Camel Squadron* (1934). New adventures appeared in the subsequent novels – 102 in all (many of which can be seen in this photograph) – which charted Biggles's lengthy career in the Royal Air Force, and introduced a number of other characters, notably Worrals, Squadron Officer Joan Worralson of the Women's Auxiliary Air Force (WAAF), who had several books of her own.

The best qualities of Biggles are found in the early books. These flying stories were a timely mixture of traditional adventure given an additional dimension by what was then new technology. Johns brought alive the terror of the flying missions and the skills of the pilots in bringing them off, all of which he dressed up in high drama. He continued the Biggles stories throughout the Second World War, although the adventures became formulaic and less convincing and the attitudes increasingly xenophobic. He also wrote some science fiction and, perhaps unexpectedly, *The Quest for the Perfect Planet* (1961), in which he explored some of the dangers of the arms race.

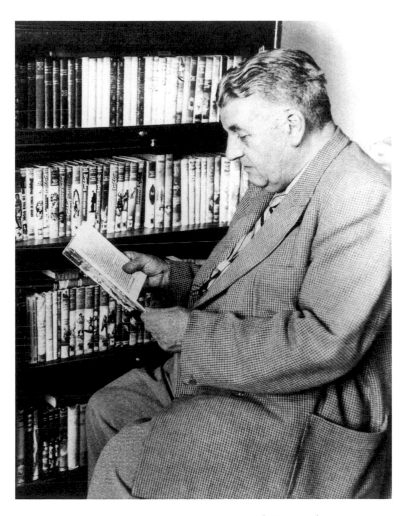

Captain W.E. (William Earle) Johns, 1893–1968
Unknown photographer, 1960
Press photograph, 508 x 406mm (20 x 16")
National Portrait Gallery (NPG RN36394)

EDWARD ARDIZZONE

1900–79

LITTLE Tim, the small boy with his brown suitcase who runs away to sea to have adventures, epitomises the independence achieved by bravery that is the stuff of children's dreams. Little Tim survives storms and harsh treatment on deck; he finds kindness and is hailed as a hero but, crucially, he always returns to the security of home – in the end. In Ardizzone's distinctive line drawings Tim's emotions are easily read, while the drama is told as much by the speech bubbles as the printed story.

Edward Ardizzone was born in Haiphong, Vietnam, where his Italian father lived and worked. At five he came to England and began the pattern of boarding school and living with relatives in the holidays that lasted for the rest of his childhood. Ardizzone left school at seventeen to work as a clerk in the City, but continued to study art through evening classes at Westminster School of Art. His earliest paid work was for black-and-white illustrations for book jackets and adult novels, but he became well known for his cartoons in the *Radio Times* and for his line and watercolour pictures of everyday street life.

Ardizzone worked at home and was constantly in the company of his children, Philip and Christianna, and it was for them when they were five and six that he wrote and illustrated his first picture book *Little Tim and the Brave Sea Captain*. First published in the United States in 1936, where the new process of offset lithography was more readily available, the first edition of *Little Tim* appeared in the distinctive large format that Ardizzone so favoured. It was published later that year in Britain and was not an immediate success (that came in 1955, after Ardizzone had reworked it) but he produced two more picture books, including *Lucy Brown and Mr Grimes* (1937), which, with its storyline of an old man befriending a little girl, was deemed unacceptable by American librarians.

Ardizzone's production of children's books ceased during the Second World War when he became an official war artist, illustrating life on the home front as well as recording his experiences overseas. After the war Ardizzone returned to the Little Tim stories with several further adventures, including *Tim All Alone*, which won the first Kate Greenaway Medal in 1956.

As an illustrator of other authors' work, Ardizzone also made a lasting impression in novels such as Philippa Pearce's *Minnow on the Say* (1955), Clive King's *Stig of the Dump* (1963) and his cousin Christianna Brand's *Nurse Matilda* (1964).

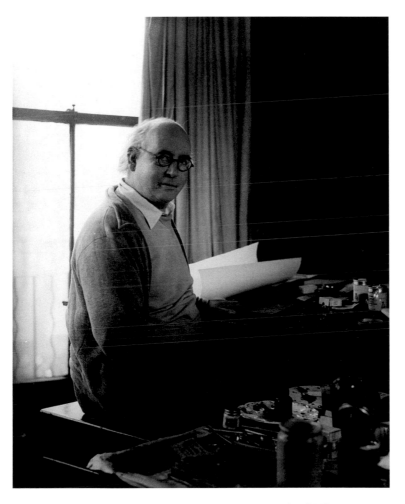

Edward Ardizzone, 1900–79
Howard Coster, 1954
Cream-toned vintage print, 240 x 190mm (9$\frac{1}{2}$ x 7$\frac{1}{2}$")
National Portrait Gallery (NPG x45739)

NOEL STREATFEILD

1895–1986

NOEL Streatfeild claimed that her success as a children's writer was dependent on her ability to think herself back into her own childhood. In *A Vicarage Family* (1963), her autobiographical novel, she records these memories against a background that recounts the family's poverty and their need to 'make the best of things', both recurrent themes of many of her novels.

Streatfeild was the second of five children of a clergyman. Like many of her fictional characters, Streatfeild felt overshadowed by her two sisters, conscious that she was considered plain and naughty. Her best talents were as an actress and, after working in the munitions factory at Woolwich Arsenal during the First World War, she joined the Academy of Dramatic Art, London (later RADA). Streatfeild acted, although not especially successfully, for ten years. But those years gave her an intimate knowledge of the theatre and the self-discipline it requires that permeates many of her books. In some she used the theatre itself, as in *The Painted Garden* (1949). In others she took as her theme the combination of hard work and luck needed for theatrical success and transposed it to other worlds – as in her ballet stories, most notably in *Ballet Shoes* (1936) but also in *Tennis Shoes* (1937) and, much later, in her book about music, *Apple Bough* (1962).

Streatfeild's first book, *The Whicharts* (1931), was an adult novel. Structured much as her subsequent children's books were to be, it is the story of three girls trying to succeed in show business. Other adult novels followed, and it was the critics who spotted Streatfeild's talent for describing children. Reluctantly, but encouraged by her publisher, Streatfeild changed direction and rewrote *The Whicharts* as the children's book *Ballet Shoes.*

The story of the three girls was an immediate success. Streatfeild introduced a new breed of child into children's fiction. Her characters always work hard for their living and towards their chosen career: they earn money from their talents and put it back to pay for future training. These are family stories about daily working life, not adventure holidays. *Ballet Shoes* was quickly followed by *The Circus is Coming* (1938), which won the Carnegie Medal.

Streatfeild's output for children slowed from 1939, when she joined the Women's Voluntary Services for the duration of the Second World War, but from 1945 onwards she produced over thirty more books, returning again and again to the theme of children developing their talents to pursue an interesting career and, above all, to make money.

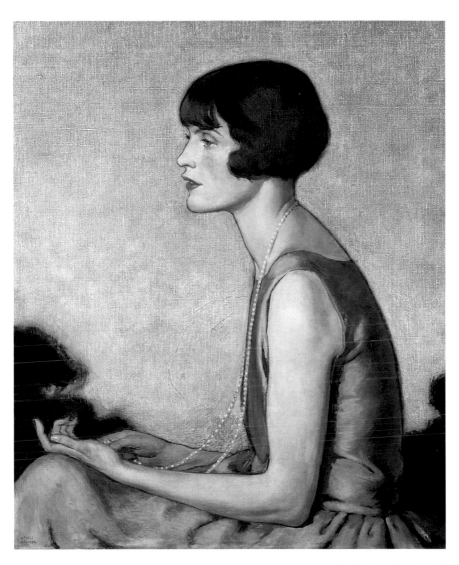

Noel Streatfeild, 1895–1986
Lewis Baumer, exhibited 1926
Oil on canvas, 762 x 635mm (30 x 25")
National Portrait Gallery (NPG 5941)

J.R.R. TOLKIEN
1892–1973

BORN in South Africa, J.R.R. (John Ronald Reuel) Tolkien was brought to England when he was three. His father died when he was very young and his mother when he was twelve. Thereafter, Tolkien was in the charge of a priest who oversaw his education. Tolkien won an exhibition to Oxford University, where he was a distinguished student, concentrating especially on languages. He continued his study of languages as a university teacher, becoming Professor of Anglo-Saxon at Oxford at the age of thirty-three.

Tolkien had a deep love for fairy stories and for the Norse and Teutonic legends, and it was in part from these that *The Hobbit*, Tolkien's first published book for children, was drawn. The origin of the tale lay in stories Tolkien had made up for his children in the 1930s – although he repudiated his publisher's claim that they had first been told in the nursery, making it clear that he did not regard *The Hobbit* as a story for the very young. Nevertheless, it is a story that has great appeal for children, and its acceptance by Sir Stanley Unwin, the publisher, was confirmed by the enthusiastic endorsement of Unwin's eleven-year-old son.

Unfashionable at the time of its publication in 1937, when social realism was popular and magic was not, *The Hobbit* was immediately recognised as a most significant contribution to writing for children. Its success was such that Allen & Unwin were keen to have a sequel. Tolkien made some starts but felt that he had already used up most of his material. He worked slowly on the new book, often giving up for periods of time and only continuing when encouraged by reading chapters aloud to colleagues, especially C.S. Lewis. As a distraction from the major project Tolkien wrote another children's book *Farmer Giles of Ham* (1949), while the new story about Middle Earth developed slowly .

Once written, it became clear that *The Lord of the Rings* (1954–5), published in three volumes all within twelve months, was not specifically a children's book but more an adult book that appealed also to younger readers. Tolkien certainly never intended it to be a book for children, claiming that it was impossible to write specifically for them. With its central theme of how honest people, however small, can overcome evil, *The Lord of the Rings* became an overwhelming success. Identification with the very ordinariness of Bilbo and Frodo, combined with the power of Tolkien's grand vision and the rich language of his writing, have made *The Hobbit* and *The Lord of the Rings* exceptional as books for children.

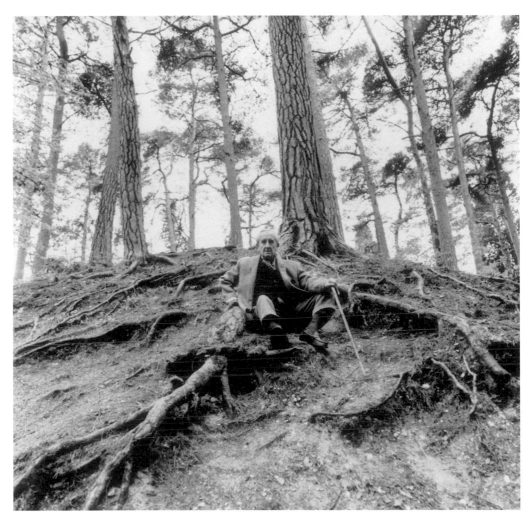

SINCE its first publication, *The Lord of the Rings* has had a cult following, especially among students and in the United States in particular. For these devotees – and many others – 2001 brought the release of a visually stunning, award-winning film version of *The Fellowship of the Ring*, the first part of the trilogy. All three books were filmed in New Zealand over a sixteen-month period with a British and American cast including Sir Ian McKellen as Gandalf, Ian Holm as Bilbo Baggins and Elijah Wood as his nephew Frodo.

J.R.R. (John Ronald Reuel) Tolkien, 1892–1973
Snowdon, 1972
Vintage bromide print, 273 x 270mm (10³/₄ x 10⁵/₈")
National Portrait Gallery (NPG P843)

KATHLEEN HALE

1898–2000

KATHLEEN Hale's father died when she was five and for the next few years she was brought up largely by her grandparents and an aunt while her mother worked. She was thought of as a 'difficult' child and was sent to board at her school in an attempt to make her more manageable, but she never conformed and spent a great deal of time resisting learning. Her interest was drawing and she attended life-drawing classes before taking up a scholarship in the art department at Reading University.

After art school, Hale moved to London where she became part of the artistic community and worked as a secretary to the painter Augustus John (1878–1961). She kept up her own drawing and drew the animals in London Zoo whenever she could afford the entrance fee. In 1918, despite being a pacifist, she enlisted in the Land Army and drove heavy carts of produce to Covent Garden Market. She married in 1926.

It was for her two sons that Hale wrote her first Orlando story *Orlando, The Marmalade Cat: A Camping Holiday* (1938). Living in the country with many cats, including a marmalade one called Orlando, she wrote of a camping holiday, with cats as the characters. She based the kitten Tinkle on her memories of herself as a child, trying to show that however wilful, all children need love and understanding. 'I began writing my books for my own children,' she wrote, 'then I wrote for children who were deprived of family love – especially those evacuated during the last world war. I've tried to keep the parent relationship, with love and understanding, alive for children who are denied it. I also wrote the books for my own rather cold childhood, thereby living out a warmth that was lacking when I was a child.'

Hale's books were expensive to produce, as she insisted on full colour and a large format that was inspired by her love of Laurent de Brunhoff's *Babar the Elephant* stories. The books got off to a slow start, and the original *Orlando* might never have had a sequel, but for the launching of Penguin's Picture Puffins in 1941 with *Orlando's Evening Out*, a paperback version that was cheaper to produce and therefore more affordable. Hale continued to work in large format and the Orlando series finally ran to over twenty titles. Orlando became hugely popular – even 'appearing' in a ballet performed at the opening of the Festival of Britain in 1951.

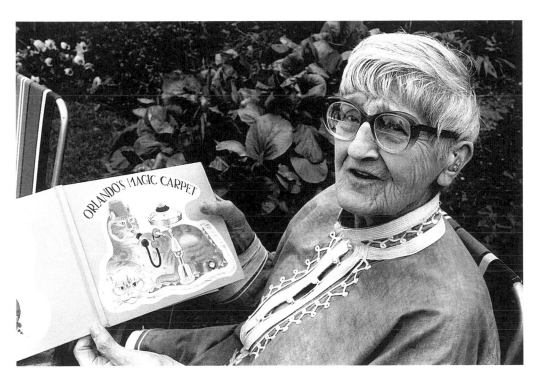

Kathleen Hale, 1898–2000
Unknown photographer, 1988
Modern print, 406 x 508mm (16 x 20")
Courtesy of *The Times*

1940s & 1950s

In the aftermath of the Second World War, fantasy stories and action-packed adventures allowed children to escape the harsh realities of domestic life and find new hope for a brighter future.

ENID BLYTON
1897–1968

ENID Blyton's influence in encouraging children's enthusiasm for books has been far reaching; certainly, a great many adults acknowledge that their love of reading comes from her books. The notion of childhood that her stories foster appears to feed an ideal with which children identify and it is for this, rather than for the quality of her writing, that Blyton is so popular.

As the author of over 700 books and 10,000 short stories, Blyton's storytelling is variable. At her best, however, she was able to write well-crafted magical adventures, such as *The Magic Faraway Tree* (1943), as well as to create long series that may seem repetitive and undemanding to adults but which, partly for those very reasons, offer compelling reading to many children. Blyton's skill lay in creating a benign world in which everything could be explained and resolved. There is no darkness or doubt in her stories, and the children are able to solve the problems that come their way. They tunnel their way – literally and metaphorically – through their landscape, led on by the beam of a torch; as a collective, they overcome adversity and enjoy each triumph. For Blyton's readers who were living with the threat of defeat by the Germans, such heroism and achievement was valuable make-believe.

The success of the Noddy books, in particular, made her a household name, but also provoked the negative reaction that was to dog her writing thereafter. Despite her obvious popularity with children themselves, her books were criticised, especially by librarians and teachers, for their limited vocabulary, stereotypical characters, simplistic emotions and, in the more politically correct 1960s and 1970s, sexism and racism.

Brought up in the London suburbs, Blyton's childhood was far from the idyllic or trouble-free one that she created in her stories. Her father abandoned the family when she was a teenager and, having fallen out with her mother, she herself left home soon afterwards. Blyton was determined not to lead the restricted, domestic life of her mother. Having taken up writing as a solace, she quickly decided that it was how she wanted to earn her living. Her family thought most of it a waste of time – they

Noddy and his car
Illustration by Harmsen Van Der Beek, *c.*1949–53
Chorion

Happy Christmas, Five!

Christmas Eve at Kirrin Cottage — and the Five were all there together! They were up in the boys' bedroom, packing up Christmas presents in gay paper. Timmy was very excited, and nosed about the room, his long tail wagging in delight.

"Don't keep slapping my legs with your tail, Tim," said Anne. "Look out, George, he's getting tangled up with your ball of string!"

"Don't look round, anyone, I'm packing up your present," said Dick. "My word — there'll be a lot to give out this Christmas, with all of us here - and everyone giving everyone else something!"

"I've a B-O-N-E for Timmy," said Anne, "But it's downstairs in the larder. I felt sure he'd sniff it out, up here."

"Woof," said Timmy, slapping his tail against Anne's legs again.

"He knows perfectly well that B-O-N-E spells Bone, Anne," said Julian. "Now you've made him sniff all about my parcels! Timmy - go downstairs, please!"

"Oh no - he does so love Christmas time, and helping us to pack up parcels," said George. "Sit, Timmy. SIT.

Original manuscript for *Happy Christmas, Five!* Published in the *Princess Gift Book for Girls*, 1961 Typescript, 255 x 205mm (10³/8 x 8¹/8") Chorion

wanted her to train as a pianist. Blyton had always loved music but she abandoned a place at the Guildhall School of Music and instead trained as a kindergarten teacher.

Like most writers, much of Blyton's early writing was rejected and she once admitted that at the beginning of her career she had numerous rejections. Nevertheless she remained undaunted, entering literary competitions and reading the works of other writers in the hope that she could learn more about technique. Her first success was with *Child Whispers* (1922), a collection of verse, and by the late 1920s she had established herself as a prolific contributor of stories and poems to magazines and especially to the magazine *Teacher's World*, which had a committed following in British schools. Books of stories about fairies, animals and brownies followed, but it was only in the late 1930s with *The Adventures of the Wishing Chair* (1937) and *The Enchanted Wood* (1939) that she became established as a writer.

Blyton could write 10,000 words a day, a remarkable feat, which enabled her to produce a prodigious output of around fifty titles a year when at her peak. The endless flow of these titles, including her adventure stories about the Famous Five and the Secret Seven and her school stories set at St Clare's and Malory Towers, quickly sealed her success and she went on to become by far the highest earning children's author of her generation: she was reported to be earning £100,000 a year by the late 1950s. The Blyton appeal is international and she continues to attract new readers around the world – her Noddy books have recently been translated and published in China.

Enid Blyton™

ENID Blyton's books have been extensively adapted for television. There have been four television series of Noddy, Blyton's most famous creation, beginning with a puppet version in the 1950s. In the 1990s, the BBC produced an animated series that was sold to over forty countries worldwide and, most recently, Chorion, the company which own the rights to the works of Enid Blyton, produced a new series called *Make Way For Noddy*, which uses the latest in digital technology.

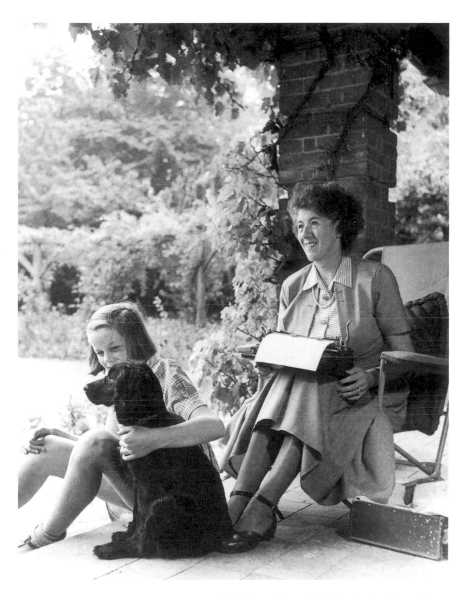

Enid Blyton, 1897–1968, with her daughter Imogen, b.1935
John Gay, 1949
Bromide print, 290 x 244mm (11³/8 x 9⁵/8")
National Portrait Gallery (NPG x47292)

DIANA ROSS

1910–2000

ALTHOUGH better known as an author, Diana Ross trained as an artist at the Central School of Art in London and was an art teacher in the early 1930s, some years before she wrote her first book for children. Ross was born in Valletta, Malta, of Canadian parents but grew up and was educated in England. The roots of her books lay in the stories she told first to her brother and sister during childhood and, later, when as a teacher she told stories to her classes as a way to get them to construct and tell their own stories. After marriage, Ross continued her storytelling with her own children and began to

write her stories down. The idea for the Little Red Engine series came from a bedtime story that she told to a young nephew who lived above a railway cutting on a branch line.

Ross had a strong sense of timing and of audience responses. Much of her writing was for BBC Children's Hour and *Listen With Mother*. She also wrote successful scripts for the children's television series *Camberwick Green*. Many of her stories were based on true details of family life, which she then embellished, and were in keeping with the new fashion for what Ross described as 'coat-and-gumboot stories about ordinary children doing ordinary things'.

Ross's most lasting success, however, has been the Little Red Engine series. *The Little Red Engine Gets a Name*, the first story about the little train, was

The Golden Hen
Written and illustrated by Diana Ross (Faber & Faber, 1942)

The Story of the Little Red Engine
By Diana Ross, illustrated by Leslie Wood (Faber & Faber, 1945)

published in 1942, before the Revd W.V. Awdry had begun his Thomas the Tank Engine stories. Like Thomas, the Little Red Engine has a definite personality: he is a worker, offering his services to the community who love him for it – a message very much in keeping with the mood at the time the books were published, when service and social equality were highly valued.

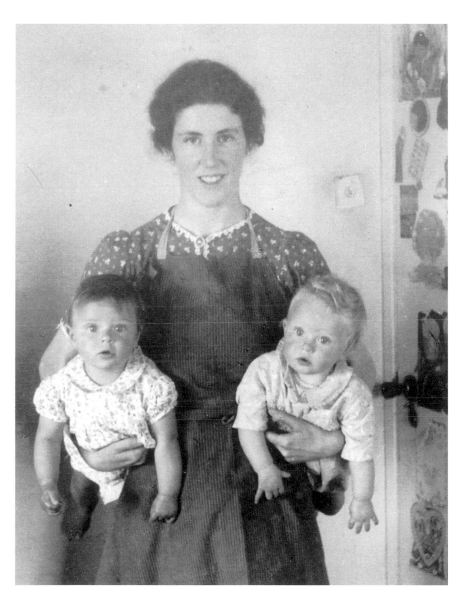

**Diana Ross, 1910–2000, with her twin
daughters Theresa and Sarah, b.1942**
B. Sachsel?, April 1943
Bromide print, 172 x 127mm (6³/₄ x 5")
Private Collection

THE REVD W.V. AWDRY
1911−97

THE inspiration for the stories of the Revd W.V. (Wilbert Vere) Awdry, best known as the 'Thomas the Tank Engine man', lay in his childhood. His father, who was also a vicar, had a model railway in his garden and, when tired of playing with that, liked nothing better than taking his young son for a walk along the railway lines near their home in Hampshire.

Awdry followed his father professionally and also inherited his passion for railways. He was ordained in 1936, but his career quickly ran into difficulties: he became a pacifist in 1937 and at the outbreak of the Second World War in 1939 had to leave his parish after a disagreement with his vicar. A new curacy was found for Awdry in King's Norton, Birmingham, where, by now married and with two children, he learnt to deal with the problems of city life. Like many other children's authors, Awdry's stories were originally intended for his own children. His son Christopher had measles and having entertained him with a traditional rhyme about trains that Christopher much enjoyed Awdry wrote it down, illustrating it with pictures of trains with faces. It was the sad face that captured Christopher's imagination and led Awdry to invent his first engine, Edward. Gordon soon followed, named after a bossy boy who lived down the road, and then Henry, the engine who would not go out in the rain.

Stories about the trains were told night after night, with Christopher putting his father right when he made mistakes. Christopher himself said, 'I gather that I got to know the stories so well that I began to correct father when he went "wrong". So he wrote them down as a form of self-defence, so he could get the words right next time!' Turned down by several publishers, Awdry's first three stories were eventually published in 1945 in one book, *The Three Railway Engines*. Awdry's original illustrations were scrapped, much to his regret, but the stories, with their engine characters ruled over by the Fat Controller, were so successful that he was invited to write more. *Thomas the Tank Engine* followed in 1946, confirming Awdry's ability to create engaging characters in dramatic situations.

So began a writing career that led to the creation of a fantasy world – the Island of Sodor. Although begun in the steam age, his railway stories nevertheless managed to adapt and survive not only the passing of steam but also the decline in railway travel itself. Christopher Awdry has continued the railway stories for a new generation, starting with *Really Useful Engines* (1983).

The Revd W.V. (Wilbert Vere) Awdry, 1911–97, with
his son Christopher Awdry, b.1940
Trevor Ray Hart, 1995
C-type colour print, 291 x 290mm (11^1/$_2$ x 11^3/$_8$")
National Portrait Gallery (NPG x76551)

THOMAS the Tank Engine and Friends, a model
animation series made for television from 1984 onwards,
was produced originally by Britt Allcroft (Thomas) Ltd
and narrated by Ringo Starr. The success of the television
series and the widespread merchandising that followed
created a multimillion pound business, making Thomas a
household name.

ANTHONY BUCKERIDGE

b.1912

ANTHONY Buckeridge's stories of Jennings, 'an eager, friendly-looking boy of eleven with wide-awake eyes and a fringe of untidy brown hair' who became the archetypal prep-school boy of the 1950s, came from close observation. The son of a bank clerk who was killed during the First World War, Buckeridge was sent to a boarding school in Sussex when he was eight. On leaving school he worked in a bank but soon realised that it was not the career for him and, after serving in the National Fire Service from 1939 to 1945, he moved instead to teaching at St Lawrence College, Ramsgate.

It was there that Buckeridge got the inspiration for his stories, modelling Jennings on some of the boys in the school. The Jennings stories were first told to the boys at St Lawrence and were then written as radio plays for broadcast on BBC Children's Hour from 1948 until 1974, winning the biennial Children's Hour Request Week for the next sixteen years. Once firmly established on radio, Buckeridge decided to re-tell the stories in books, of which he produced twenty-five from 1950 to 1994.

Set in the enclosed world of Linbury Court School, a tiny boarding school in the country, the experiences of Jennings, his friends – and their long-suffering masters – were far removed from those of most British school children even when they were written; indeed, with their strong element of farce, the stories owe as much to the writing of P.G. Wodehouse (1881–1975) as to the 'realism' of traditional school stories. Buckeridge never felt the need to change the age of his characters: Jennings and Darbishire and their friends remained at a constant eleven years old.

In addition to the Jennings books, Buckeridge wrote another successful school story series, the four Rex Milligan books. He also wrote *A Funny Thing Happened!* (1953), which was adapted as a radio play in 1963. Buckeridge left teaching in 1950, becoming a full-time writer and actor, including playing small mute parts at the Glyndebourne opera.

Anthony Buckeridge, b.1912
Duncan Fraser, 1982
Glossy resin-coated print, 165 x 249mm (6¹/₂ x 9³/₄")
National Portrait Gallery (NPG x20065)

ORIGINALLY written for BBC Radio, the Jennings stories came almost full circle in the 1990s with Stephen Fry's excellent reading of them on audio tape, again for the BBC. Jennings's fortunes waned as the kind of education he enjoyed went out of fashion, but 2001 saw a revival of his popularity – partly as a result of the enthusiasm for J.K. Rowling's Harry Potter books – and his adventures are now being published in the United States for the first time.

C.S. LEWIS

1898–1963

C.S. (Clive Staples) Lewis was born in Belfast. His mother died when he was nine and he and his brother were brought up by their father, who was a solicitor. During his childhood Lewis created the imaginary country of Bloxen. In his reading he was much influenced by E. Nesbit's novels, especially the 'magic' ones such as *The Story of the Amulet* (1906). He also read the Norse myths and, at sixteen, discovered Homer's *Iliad* and *Odyssey* and then George MacDonald's *Phantastes* (1858). From all of these he drew inspiration when he came to write his own children's stories, later saying 'I wrote the books that I should have liked to read'.

Lewis went to University College, Oxford, where he was a distinguished student before becoming a Fellow of Magdalen College, Oxford, in 1923 – a position he held until he moved to be Professor of Medieval and Renaissance English at Cambridge University in 1954. It was during his time at Oxford that Lewis met J.R.R. Tolkien and, with him, formed 'The Inklings', a group of like-minded friends who met and discussed writing. Under Tolkien's influence Lewis returned to Christianity – although brought up in the Church of Ireland, he had become an atheist in the intervening years. Under Tolkien's influence, too, he began to write his *Chronicles of Narnia* (1950–6), but the seeds of his stories, he has claimed, lay in his childhood: 'I am a product of long corridors, empty sunlit rooms, upstair indoor silences, attics explored in solitude, distant noises of gurgling cisterns and pipes, and the noise of wind under the tiles. Also of endless books.'

Lewis wrote the *Chronicles of Narnia* apparently inspired by a desire to convey a morally didactic kind of Christianity to children through the medium of fantasy. The result displays an amazing talent for invention. The books were excellently received at the time, although it was not until 1957 that Lewis won the Carnegie Medal for *The Last Battle* (1956).

Although the *Chronicles of Narnia* were published as children's books, Lewis intended his books to have a far wider appeal, especially as both he and Tolkien believed in the power of stories to give mental and moral nourishment.

Fifty years after their publication the *Chronicles of Narnia* continue to top polls of popular children's books, but this popular acclaim disguises the controversy that still surrounds them and masks the differences of opinions about Lewis's intentions in writing them.

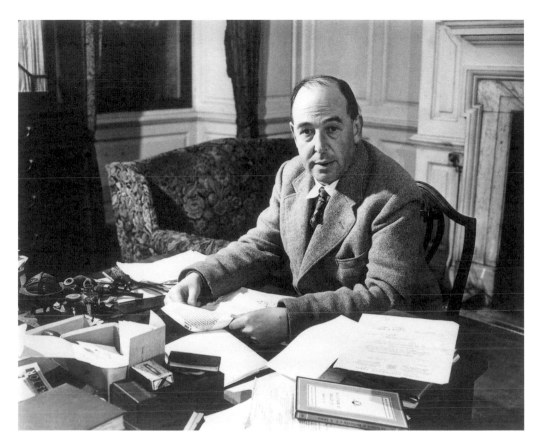

C.S. (Clive Staples) Lewis, 1898–1963
Arthur Strong, Magdalen College, Oxford, 1947
Bromide print on Ilford Galerie paper
245 x 300mm (9⁵/₈ x 11³/₄")
National Portrait Gallery (NPG x19828)

TREVOR Nunn's large-scale production of *The Lion, the Witch and the Wardrobe* (1950) for the Royal Shakespeare Company opened in Stratford in December 1999. There have also been several adaptations for television. The story of Lewis's own life has been told in *Shadowlands*. Written by William Nicholson, it was produced for television in 1985, with Joss Ackland as Lewis, and as a film in 1993, with Sir Anthony Hopkins in the lead role.

MARY NORTON

1903–92

THE idea for the Borrowers – a tiny family living in a restricted world under the floorboards in which a safety-pin makes a gate and the top half of a knight from a chess set becomes a statue for the sitting room – came from Mary Norton's own short-sightedness as a child. Peering closely at things, Norton saw the minute details that led her to create a fantasy world inhabited by a diminutive race.

Brought up in a Georgian manor house near Leighton Buzzard in Bedfordshire, which later became the setting for her stories about the Borrowers, Norton was educated at a convent school before pursuing her first ambition as an actress. From 1925 until her marriage the following year, she acted with the Old Vic Theatre Company in London.

Marriage to a member of a shipping family took Norton to Portugal, where her two children were born, and then to New York, where she wrote her first book *The Magic Bed-Knob; or How to Become a Witch in Ten Easy Lessons* (1943). Later revised as *Bedknob and Broomstick*, the book was a gentle, humorous fantasy of Miss Price, an amateur witch with a conscience. More stories in a similar vein followed before Norton wrote *The Borrowers* (1952). The book's success was immediate; it won the Carnegie Medal and over the following years, in a number of sequels, the Borrowers went out into the world to have adventures.

The story of this tiny family – Pod, Homily, their daughter Arrietty and their relatives – is captivating for the detail of their existence, as well as for the social commentary that underpins it. But the book's lasting success comes from more than just its close-up view of tiny people. At its heart, through Arrietty, *The Borrowers* is exceptional in capturing the yearning and inner feelings of an adolescent frustrated by the limitations of her parents' way of life.

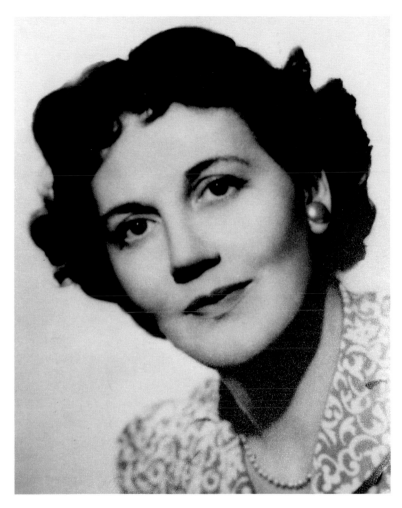

Mary Norton, 1903–92
Unknown photographer, c.1950s
Sepia-toned bromide print,
230 x 180mm (9 x 7 1/8")
Private Collection

BEDKNOBS and Broomsticks, the title given to the 1971 Walt Disney film, was a stunning blend of live action and animation. The first adaptation of *The Borrowers* was for television in the United States in 1973. The book has subsequently been adapted twice for British television, most recently in 1993. The film version of 1997 brought the tiny characters to life on the big screen.

ROSEMARY SUTCLIFF

1920–92

'HISTORY is not a collection of isolated set pieces. It is a continuous process and very much alive.' For over thirty years, Rosemary Sutcliff brought living history to generations of children with her many accurate, dramatic and moving historical novels, including *Warrior Scarlet* (1950), *The Eagle of the Ninth* (1954) and the Carnegie Medal winning *The Lantern Bearers* (1959).

Sutcliff was two when she was diagnosed with Still's disease, a rare form of juvenile arthritis that made it difficult for her to walk and later confined her to a wheelchair. As a result, she had long and painful periods in hospital in an attempt to improve her condition. Sutcliff hated school and left when she was fourteen to attend Bideford Art School, Devon, where she was taught painting. On the advice of others – who thought that it would provide a suitable occupation for her – Sutcliff became a miniaturist. She achieved considerable success at this: her work was shown at the Royal Academy of Arts, London, and she became a member of the Royal Miniaturist Society.

It was not until the end of the Second World War, when she was twenty-five, that Sutcliff took up writing. At first it was a way of escape, especially as she kept her writing entirely secret because she did not think her family would have any confidence in her ability. Hiding the sheets of foolscap under blotting paper she wrote out her first adventures – an early one of which was a saga of the Roman invasion of Britain told from the British viewpoint, a precursor to *The Eagle of the Ninth*, the first of her Roman novels and the book that remained her favourite throughout her life.

There were many false attempts before Sutcliff wrote something she thought worthy of publication. Designed for children, it was a re-telling of the Celtic and Saxon legends that her mother had read to her as a child. Although it was rejected, the publisher did suggest that she tried her hand at a re-telling of the story of Robin Hood. However, it was *The Queen Elizabeth Story* (1950), not *The Chronicles of Robin Hood* (though this was published in the same year) that began Sutcliff's writing career. Her writing is influenced by the work of those authors that her mother had read to her, Kenneth Grahame's *The Wind in the Willows* and Rudyard Kipling's *Just So Stories* (1902) and *Puck of Pook's Hill* (1906). She once claimed that her style came from advice given to her by her father, who wrote Admiralty sailing reports: 'never to use two words if one will suffice'.

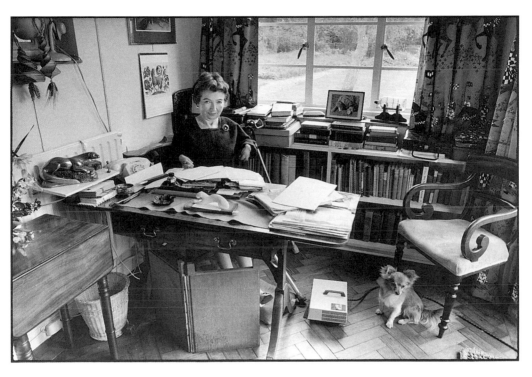

Rosemary Sutcliff, 1920–92
John Timbers, 1970
Bromide print, 263 x 389mm (10³/8 x 15³/8")
National Portrait Gallery (NPG x125110)

WILLIAM MAYNE

b.1928

WILLIAM Mayne is known for his reluctance to speak to journalists. When once asked if he was willing to be interviewed for a children's books magazine he replied:

> I am sure this sort of thing never works. I shall go nowhere to accomplish it, and I'm sure others would find it unrewarding to come here. I have not sensed the lack in my not appearing in your neologies . . . but if you find it necessary to molest my ancient solitary peace for the sake of your new and maddening piece, I am prepared to tolerate for a short time some person guaranteed not to be strident.

Mayne lives in the Yorkshire Dales. He was born in Hull, the eldest child of a doctor. Mayne left school at seventeen and has dismissed his time there as unimportant claiming, 'I gave up thinking school was any good at fourteen, though social pressures didn't allow one to abandon it'. However, his quartet of choir-school stories, which began with *A Swarm in May* (1955) and is set in Canterbury where Mayne was a schoolboy chorister, indicate the lasting influence of those years.

Mayne decided to become a writer at fourteen and, after only a brief spell working for the BBC and as a teacher, he has been writing ever since. From the first, his writing has been distinctive, recognisable not least for its economy of style. Mayne uses dialect that gives an immediacy and individuality to his characters and the blunt and often elliptical use of language is a hallmark of all his books, as are the wit and the puns – including puns in Latin in the choir-school quartet.

The publication of *A Grass Rope* (1957), which won the Carnegie Medal, established Mayne's reputation. What became familiar themes in his subsequent novels – the way the past affects the present and the power of the history locked into a landscape to shape a story – broke new ground and defined Mayne as an author of exceptional originality for all ages.

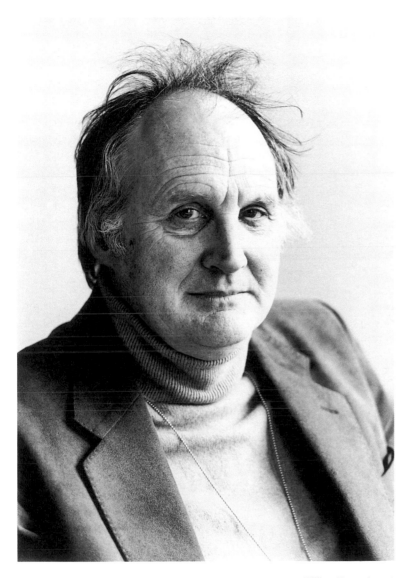

William Mayne, b.1928
Carole Cutner, 17 April 1985
Bromide print, 296 x 203mm (11⁵/8 x 8")
National Portrait Gallery (NPG x26051)

DODIE SMITH

1896–1990

DOROTHY Gladys Smith (she preferred to be known as 'Dodie') was brought up in an atmosphere steeped in the theatre, literature and an appreciation of fine things. She began writing a diary when she was eight, a habit she continued all her life; she enjoyed observing people and recording her thoughts about them. Her first love was the theatre and her ambition was always to become an actress. At thirteen Dodie started taking parts in amateur dramatic productions with her uncles and she sang, danced and acted well enough to be thought to have some talent.

Dodie determined that she would go to the Academy of Dramatic Art (now RADA), even though she was under five foot and was generally considered plain after childhood, with noticeably prominent teeth. She was accepted and spent two years acting – with very little success – living in considerable poverty but very much enjoying a fast life as a 'flapper'.

When it became clear that she was not going to succeed as an actress, Dodie found a job in Heal & Son, the family-owned furniture store in London, which she later said provided her with most of the inspiration for her plays. She certainly provided herself with considerable inside knowledge of complicated liaisons, having several affairs with married men, including Sir Ambrose Heal who was then managing the firm. She later married Alec Beesley, another colleague, who was seven years her junior.

While at Heal & Son, Dodie wrote her first play *Autumn Crocus* (1931), which was an immediate success. She followed it with several others, most notably *Dear Octopus* (1938). These established her reputation as one of the more successful playwrights of her day. During the Second World War, which she spent in the United States, Dodie switched from writing plays to writing novels. *I Capture the Castle* (1949) was initially intended for adults but its romantic setting and its story of two sisters living in penury with their exotic stepmother and eccentric father made it popular with teenagers, too. She wrote only three books specifically for children, *The Hundred and One Dalmatians* (1956), *Starlight Barking: More about the Hundred and One Dalmatians* (1967) and *The Midnight Kittens* (1978). Her simple morality and the values of loyalty, courage and determination in her books underlie her appeal . Having first owned a Dalmatian, Pongo, while living in London, Dodie was passionate about dogs all through her life and once she and her husband moved to the Barretts, their home in Essex, she always owned a Dalmatian.

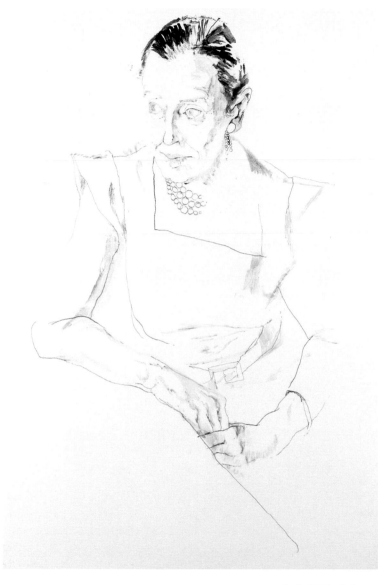

WALT Disney's award-winning animation *101 Dalmatians* (1961) brought life to the threatened puppies and set the visual style for some of Disney's greatest films for the next twenty years. The film was remade in 1996 in a live-action version less closely based on Dodie Smith's original story, and starred Glenn Close as a spectacular Cruella de Vil. Such was the film's success that it was followed up in 2000 with *102 Dalmatians*, also starring Glenn Close, which was even further removed from the original story.

Dodie Smith, 1896–1990
Don Bachardy, 1961
Pen and ink and wash, 777 x 508mm (30⅝ x 20")
National Portrait Gallery (NPG 6423)

MICHAEL BOND
b.1926

MR and Mrs Brown first met Paddington on a railway platform, which was how he came to have such an unusual name for a bear, because Paddington was the name of the station. He was wearing a strange kind of hat and he was sitting on an old leather suitcase near the Lost Property Office.

Finding a label saying 'PLEASE LOOK AFTER THIS BEAR. THANK YOU' around his neck, and having discovered that he had travelled all the way from 'Darkest Peru' with only marmalade to eat, the Browns took him home with them. From that moment on, life was never quite the same. As Paddington freely admits, '*Things* happen to me. I'm that sort of bear!'

Michael Bond drew his inspiration from a small bear he came across one Christmas Eve literally left on the shelf of a London store. He could not resist buying it as a 'stocking filler' for his wife and, some months later, finding himself with a blank sheet of paper in his typewriter and seeing the bear sitting on his mantelpiece, he began to doodle. The doodle became a paragraph, the paragraph became a chapter and, in no time at all, the chapter was joined by seven more.

A Bear Called Paddington was published in 1958 with illustrations by Peggy Fortnum. It was the forerunner of a series of thirteen novel-length books and, in 1976, Bond adapted many of the stories for television. Brilliantly animated by Ivor Wood, they were narrated by the late Sir Michael Hordern. In the meantime, while continuing to chronicle Paddington's adventures in picture book form, Bond also created *The Herbs* for television and a number of other series for children, including books about a mouse called Thursday and, more recently, a beguiling guinea pig named Olga da Polga.

Born in Newbury, Bond spent his formative years in nearby Reading before joining the BBC as an engineer. During the Second World War he served in both the RAF and the army. It was while stationed in Egypt that he sold a short story to the magazine *London Opinion* and decided that he wanted to be a writer. In 1947, back in civilian life, he worked in the BBC Monitoring Service for several years before fulfilling yet another ambition by becoming a television cameraman. In 1965 he left the BBC in order to write full time and, in 1997, he was awarded an OBE for services to children's literature.

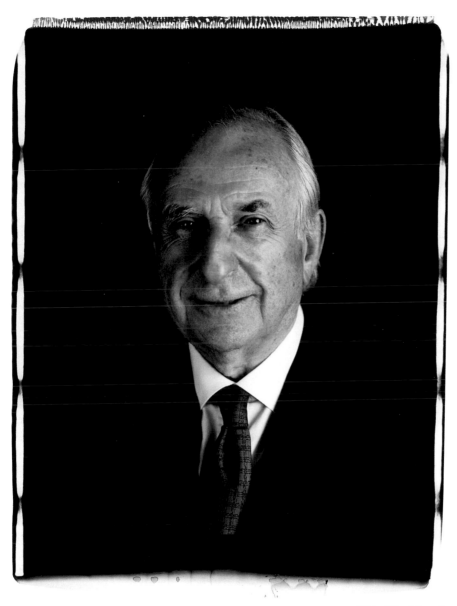

Michael Bond, b.1926
Maud Sulter, October 2001
Colour polaroid photograph, 804 x 560mm (31⅝ x 22")
National Portrait Gallery (NPG P949(3))

PHILIPPA PEARCE

b.1920

PHILIPPA Pearce had an idyllic childhood in a beautiful old mill-house on the banks of the River Cam, just outside Cambridge. Her father, like his father before him, was a flour-miller. The youngest of four children, Pearce canoed and swam with her brothers and sister, fished in the river and, in freezing winters, skated on its flooded water meadows. Pearce was ill for some of her childhood and missed the early years of school. After leaving Girton College, Cambridge, where she read English and History, Pearce's first job was as a script writer and producer for BBC Schools Radio, where she learnt to write for the ear and the inward eye. She then became an education and children's book editor, before writing her first book in her mid-thirties while recovering from tuberculosis. *Minnow on the Say* (1955) drew deeply on her childhood memories of playing on the river: Great Shelford became Great Barley; the Cam became the River Say and Castleford stood for Cambridge. The book received immediate critical attention for its excellently conceived characters and for the freshness of the story, and was runner up for the Carnegie Medal.

Tom's Midnight Garden (1958), Pearce's second book, was even more directly inspired by her childhood home. By now her father had retired and there was no future in small, locally-based flour mills. The house in which Pearce had grown up was to be sold and she imagined the possibility of it being converted into flats and its garden lost forever. Pearce wanted to recreate and 'preserve' the house and its garden as it was when her grandfather was alive. *Tom's Midnight Garden* won the Carnegie Medal and is regarded as an outstanding novel, not just for its sense of place and the magic that it conveys, but also for its underlying message about the nature and importance of growing up and the relationship between young and old, a theme to which Pearce returned in several later novels.

Pearce's love of animals and her sense of their importance in humans' lives was demonstrated in *A Dog So Small* (1962), the story of a boy's longing for a dog, and in such later stories as *The Battle of Bubble and Squeak* (1978), which was written for her daughter, a passionate animal lover. Pearce now lives with her dog and cat just down the lane from where she grew up.

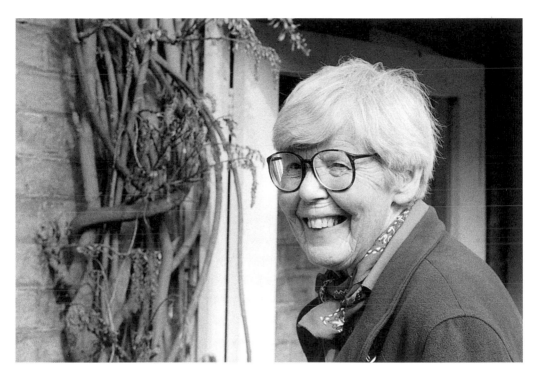

Philippa Pearce, b.1920
Helen Craig, 1997
Bromide print, 303 x 452mm (11 7/8 x 17 3/4")
Courtesy of the photographer

Whose book is it anyway?

THE twentieth century ended with the most dramatically successful children's book yet published. When J.K. Rowling outlined the plan for her seven-book Harry Potter series she thought of it as for adults, even though the central character was always a boy, albeit one growing up from eleven to eighteen. On publication, however, the first book was clearly marketed as a children's book: it was sold to children, read by children and won prizes awarded by children. Adult approval followed only later, the phenomenon spiralling to dizzy heights as the book was read the whole world over. To satisfy these new readers, the books were repackaged as adult books, with different covers giving them a new look and a fresh identity. Almost simultaneously Philip Pullman's substantial trilogy *His Dark Materials* similarly succeeded in 'crossing over' and *The Amber Spyglass* (2000), the third book in the trilogy, achieved the hitherto unimaginable feat of winning the 2001 Whitbread Book of the Year Award against competition from novels, biographies and poetry written for adults.

While these two authors have the ability to enthral both children and adults, they are by no means the first to do so. Throughout the century, and for many different reasons, classic 'children's books' have entertained readers of all ages, whatever the original intention of their authors or their publishers. Some, like the above examples, have begun published life as children's books but found readers beyond their original expectation; others, although intended originally for adults, have been adopted by children because the subject matter appeals.

Despite winning several children's book prizes for *Watership Down* (1972), Richard Adams has always resisted the labelling, adopting C.S. Lewis's view that

if a book is not worth reading at sixty it is not worth reading at six. Fortunately, Adams's book was successfully marketed for both children and adults all over the world and so has always had a wide readership, although the animated film emphasised its position as children's entertainment. Lewis himself, while championing the importance of children's books appealing to adults, wrote the *Chronicles of Narnia* specifically for children but always with the intention that adults could enjoy them, which they then did, thus endorsing his views about the value of a good story working for all ages of reader.

Although it, too, was written as a children's book, Tolkien was reluctant to restrict the readership of *The Hobbit* (1937). He wrote to his publisher objecting to the copy on the jacket flap that said he had first read the story in the 'nursery' to his own children, believing that it implied a cosiness that would limit its readership. Originally written as a sequel to *The Hobbit*, *The Lord of the Rings* (1954–5) grew both in size and complexity and, again, Tolkien never intended it to be considered as a children's book. Although many children did read it, it was more popular with adults and became cult reading for a generation of university students in the 1960s.

Henry Williamson, like Tolkien, intended *Tarka the Otter* (1927) to be for adults, and indeed it was a prize-winning adult novel before it was adopted as a suitable introduction for children to the realities of nature in 1941. For fifty years it was successfully published as a children's book but, although it remains on children's lists, modern sensibilities about animals, and particularly about the hunting of animals, have caused it be thought of as alarmingly strong meat for contemporary readers of any age.

Some of the most enduring childhood characters began life specifically for children but in a form that was equally accessible to adults. Rupert Bear made his first appearance in 1920 as a tiny sop to children in the *Daily Express*, while Billy Bunter was designed to appeal to the target readership of the boy's comic *The Magnet*. Their comic-strip style meant that they were less confined to a particular market than books and both soon had a considerable following of children and adults alike. Others, such as Richmal Crompton's *Just William* (1922), found their readers the other way round – William first appeared in a magazine story for adults. Crompton always wanted to be an adult writer, but the first book about William was published as a children's book and from then on Crompton kept up a steady supply of titles – thirty-eight in all – even though she referred to William as a 'Frankenstein monster' and longed to write for adults too.

Whether originally designed for adults or children, many of the best twentieth-century books of childhood have lasting qualities that make them worth reading again and again, and passing on to the next generation to enjoy.

1960s & 1970s

From the weird to the wonderful, the creations of Roald Dahl and Ted Hughes reflected a new spirit in children's literature. Through the combination of complex stories and illustrations, children were educated, entertained, and sometimes even appalled.

ROALD DAHL

1916–90

ROALD Dahl's parents were Norwegian, but he was born in Llandaff, Wales, where his father was the joint owner of a ship-broking business. Dahl recounted his early life in his autobiographies *Boy: Tales of Childhood* (1984) and *Going Solo* (1986). As a child he experienced both great happiness and great suffering, coming from a warm and caring family torn apart first by the death of his much-loved older sister and then, possibly as a result of grief, by the death of his father not long afterwards. However, Dahl's background provided him with an array of loving relatives with whom he enjoyed long, carefree holidays in Norway that were oases of happiness, far away from home. The contrasting cruelty that Dahl witnessed at his boarding school fuelled what became one of the most potent hallmarks of his stories – a robust championing of the weak against the strong.

Dahl left school at seventeen and went to work for the Shell Company. His career took him to Africa and he served as a pilot there during the Second World War. In his adult life, too, Dahl experienced tragedies: his son suffered brain damage when his pram was involved in an accident in New York; his first wife, the Hollywood actress Patricia Neal, had a stroke while pregnant with their fifth child; and his eldest daughter Olivia died of measles when she was eight.

Roald Dahl and characters
Cover illustration by Quentin Blake
for *The Dahl Diary 1992* (Puffin, 1991)
Courtesy of Penguin Books

The Gremlins (1943), Dahl's first book, was written for children but he then turned his hand to writing adult novels, particularly short stories, before returning to children's books almost twenty years later, after he had children of his own. *James and the Giant Peach* was first published in the United States in 1961 but it took six years for him to find a publisher for it or any of his other titles in Britain. Once published, Dahl quickly established himself as a writer for children and after *Charlie and the Chocolate Factory* (1964) he produced almost a book a year, each one increasing his reputation. Adults took much longer to accept his particular brand of humour: Dahl's first

And such wonderful things it could buy!

Very slowly, Charlie began to edge his right hand forward over the counter towards the little shiny dime. Then he placed the tip of one finger very delicately right on top of the coin, and began pushing it across the glass to the shopkeeper.

"I think," he said quietly, "I think ... I'll have just one more of those candy-bars. The same kind as before, please."

"Why not?" the fat shopkeeper said, reaching behind him again and taking another Whipped Cream Fudgemallow Delight from the shelf. He laid it on the counter.

Charlie picked it up and tore off the wrapper ... and suddenly ... from underneath the wrapper ... there came a brilliant flash of gold ...

Charlie's heart stood still.

"It's a Golden Ticket!" screamed the shopkeeper, leaping about a foot in the air. "You've got a Golden Ticket! You've found the last Golden Ticket! Hey, what do you know! Come and look at this, everybody! The kid's found Wonka's last Golden Ticket! There it is! It's right there in his hands!"

It seemed as though the shopkeeper might be going to have a fit.

"In my shop, too!" he yelled. "He found it right here in my own little shop! Somebody call the newspapers quick and let them know! Watch out now, sonny! Don't tear it as you unwrap it! That thing's precious!"

Second draft manuscript page from Charlie and the Chocolate Factory entitled 'Charlie's Chocolate Boy' at this stage, c.1961
Pencil and paper, 318 x 203mm (12 1/2 x 7 3/4")
The Roald Dahl Museum Trust

Typescript page from a near final draft of Charlie and the Chocolate Factory, c.1964
The Roald Dahl Museum Trust

award from adult critics came in 1983, when he won the Whitbread Children's Book Award for *The Witches*, the judges describing it as 'deliciously disgusting'.

Dahl's output of stories dominated children's reading for the last thirty years of the twentieth century. His books appeal to readers of all ages, although he is perhaps best loved for the book that goes right to the heart of all children – *Charlie and the Chocolate Factory*, the story of a boy who wins a ticket to the magical chocolate factory owned by the sensational Willy Wonka. Dahl appeared to have a special affinity with children that enabled him to see things from their point of view. He once said that he became 'twerpy' when writing for children, a state that allowed him to understand their view of the world and to empathise with the frustrations of their powerlessness.

Dahl's reputation has been attacked for many reasons. His stories were initially thought to be too vulgar and cruel by adult critics; *The Twits* (1980) – about a couple with disgusting habits whose sole entertainment comes from playing sadistic tricks on each other – and *George's Marvellous Medicine* (1981) have always been singled out for criticism. He has also been charged with sexism and racism. While there are examples of these in Dahl's books, there is also evidence of kindness and tenderness in many titles, including *Danny, the Champion of the World* (1975), Dahl's most openly affectionate story of a wholly loving and mutually respectful relationship between a father and his son, *The BFG* (1982) and *Matilda* (1988). Dahl's position as an author who has tempted children into the enjoyment of reading is overwhelming. His legacy as the author of stories and verse for all ages is exceptional and his particular brand of subversive humour gives fictional children new and sometimes disagreeable opportunities and power.

DAHL'S stories have been adapted in a variety of ways, reflecting their many characters, from the full-length family films *Danny, the Champion of the World* (1988) and *Matilda* (1996), to the more original animated version of *James and the Giant Peach* (1996). Plays, including *The BFG* and *The Witches*, as well as musical adaptations of *Revolting Rhymes*, have brought the works to new live audiences.

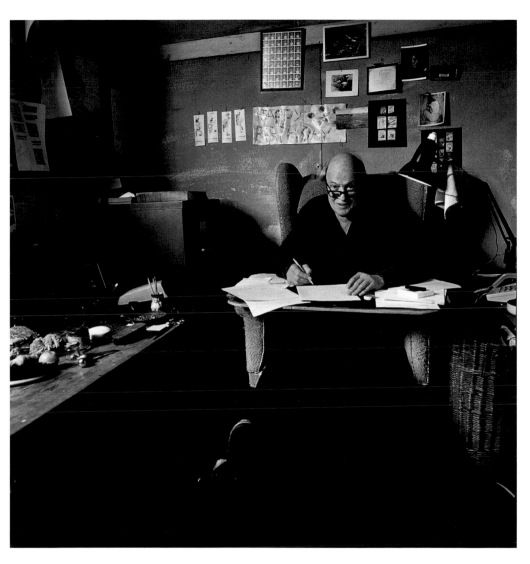

Roald Dahl, 1916–90
Jan Baldwin, 1989
Cibachrome print, 344 x 357mm (13^1/$_2$ x 14")
National Portrait Gallery (NPG x125022)

TED HUGHES
1930–98

TED Hughes is best known for his adult poetry, but *The Iron Man* (1968) is a classic children's book and his poems and creation stories for children also mark him out as having a particular affinity with young readers, something he himself recognised, saying, 'I find a common wavelength . . . between the self I was then and the self I am now'. Hughes was brought up in Yorkshire, a place that he loved and which inspired much of his poetry. After university he worked in a variety of jobs – rose gardener, night watchman in a steelworks, zoo attendant and teacher – before becoming a full-time writer. Hughes's life and adult poetry were much influenced by his marriage to Sylvia Plath (1932–63) in 1956 and her subsequent suicide. Surprisingly, the complexities of his domestic life do not surface in his writing for children.

Hughes's first collection of poetry for children was *Meet My Folks!* (1961), a humorous sequence of family poems. His first book of stories for children, a collection of creation stories called *How the Whale Became* (1963), was published long after he was already established as a leading poet. Both *How the Whale Became* and *The Iron Man* were dedicated to his two children Frieda and Nicholas. From then on, his output for children included plays, fiction and poetry, much of which is devoted to the countryside, as in *Season Songs* (1976). *What is the Truth? A Farmyard Fable For the Young* (1984), for which he won the *Guardian* Children's Book Prize and the Signal Poetry Prize, is an honest and intelligent view of animals in the countryside written for the Farms for City Children scheme, which was set up by fellow-author Michael Morpurgo.

As might be expected, Hughes was entirely unpatronising in his writing for children, believing that they would absorb whatever they were offered: 'They will accept plastic toys, if that's what they're given, but their true, driving passion is to get hold of the codes of adult reality – of the real world'.

Hughes was appointed Poet Laureate in 1984 and, in 1993, was awarded the Order of Merit. He played an active role in helping Michael Morpurgo establish the Children's Laureate, a position awarded to a children's author or illustrator for an outstanding contribution to children's books. Hughes welcomed the scheme, linking it with his own role as Poet Laureate, and endorsing the importance of writing for children.

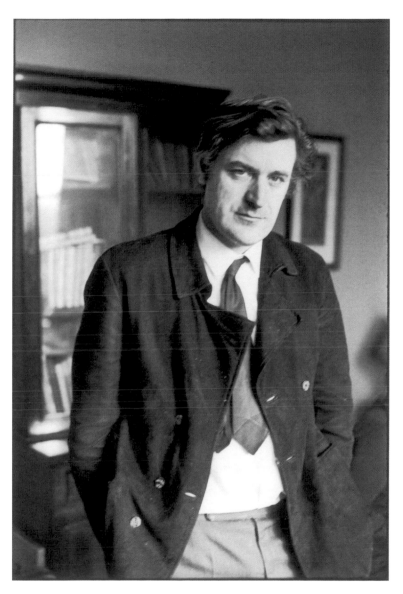

Ted Hughes, 1930–98
Henri Cartier-Bresson, 1971
Bromide print, 359 x 241mm (14^1/$_8$ x 9^1/$_2$")
National Portrait Gallery (NPG P726)

OLIVER POSTGATE

b.1925

IN 1973 Oliver Postgate and Peter Firmin (b.1928), using a primitive form of animation in a cowshed in Kent, made a film series for the BBC about *Bagpuss*. This saggy, sedentary, old cat presided over the window of Emily's shop where he and his colleagues sang songs and told stories in order to mend the broken articles that she had brought to them. In 1999 this film series was voted 'The Best Ever BBC Children's Programme'. It was not their first success in this field. Postgate and Firmin had already made Alexander the Mouse, Ivor the Engine (the Welsh engine who wanted to join the choir), the Pogles, the Pingwings and Noggin the Nog, the charming Viking prince who, in his first adventure, set sail in search of the perfect bride. Keeping abreast of interest in space exploration, they later located the Clangers, a small tribe of mouse-like persons living on an unspecified moon, somewhere 'out there'. And there were many other home-produced animated series for which Postgate wrote the stories before the homespun animation could begin.

The grandson of George Lansbury, one of the founding members of the Labour Party, Postgate was born in North London. At the beginning of the Second World War he was evacuated, and went from his highly-structured local secondary school to the progressive Dartington Hall School in Devon, an experience that he did not enjoy.

After school, Postgate went briefly to Kingston Art School until, in 1943, he was called up for active service in the war. His father, Raymond, who later founded and edited the *Good Food Guide*, had himself been a conscientious objector in the First World War and Postgate followed suit. Rejecting his call up, he was imprisoned briefly before spending the rest of the war working as a farm labourer.

After the war Postgate trained as an actor at the London Academy of Dramatic Art (now RADA) and had hopes of a career in the theatre, but acting jobs were hard to get and instead he began to work behind the scenes in the theatre and elsewhere. Always inventive and practical – he made a washing machine out of a milk churn for his mother – Postgate found work designing a set of animated displays for the Festival of Britain in 1951. In the following years he worked as the manager of a button factory and also began to write his own stories. In 1958 he wrote *Alexander the Mouse*, which was taken on as the first in a new 'magnetic animation system', so beginning a life of inventing characters and their worlds.

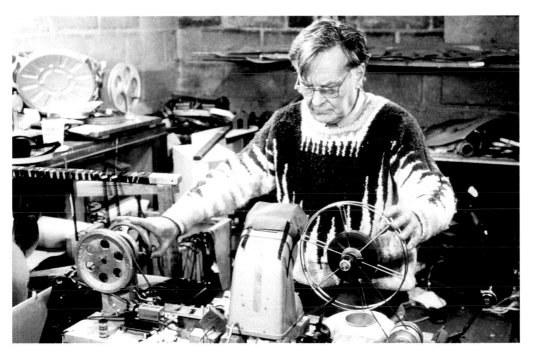

Oliver Postgate, b.1925
James Styles, *c.*1985
Colour print, 366 x 498mm (14³/8 x 19⁵/8")
James Styles

LEON GARFIELD

1921–96

LEON Garfield did not set out to be a children's writer. His first manuscript *Jack Holborn* (1964), the dramatic story of eighteenth-century piracy, was submitted as an adult novel, but the publishers felt that it had a better future as a children's book. Although his stories are often centred on children, as in *Jack Holborn*, or Tolly Smith, the boy with the travelling fair in *Black Jack* (1968), Garfield's are not books that have any other specifically childish ingredients. He himself said, 'Really what I try to write is that old-fashioned thing the family novel, accessible to the twelve-year-old and readable by his elders.'

Garfield was born and brought up in Brighton, where several of his novels are set. He moved to London, which also provides some settings, and in 1948 he married Vivien Alcock, who was herself to become a distinguished children's novelist. Garfield served in the Royal Army Medical Corps from 1940 to 1946, during which time he remained in the rank of private, a position that he later claimed afforded much contented boredom as well as many experiences on which to draw. One such experience, the disinterring of the remains of concentration camp victims, gave him an unusually direct insight into the extent of human evil. On leaving the army, Garfield worked as a biomedical technician at the Whittington Hospital in London.

Garfield's writing career began in 1964 with the publication of *Jack Holborn* and he swiftly established a reputation for his richly written, atmospheric and exciting adventures. He won the newly established *Guardian* Children's Book Prize in 1967 for his second book, *Devil-in-the-fog* (1966), and left the hospital in 1969 to become a full-time writer. Once started, Garfield became a highly prolific writer, producing approximately a book a year and covering a diverse range of subjects. Although most of his work is in novel form, generally with an eighteenth-century background, he also wrote *The Apprentices* (1982), a superb series of a dozen carefully crafted stories, each of which reflects the details of a particular eighteenth-century trade.

In addition to his own historical novels, Garfield was also gifted at adapting the stories of others. With Edward Blishen he wrote *The God Beneath the Sea* (1970), a re-telling of the classical myths that won the Carnegie Medal, and he re-told Shakespeare's plays as prose stories in *Shakespeare Stories* (1985), which he also adapted for television.

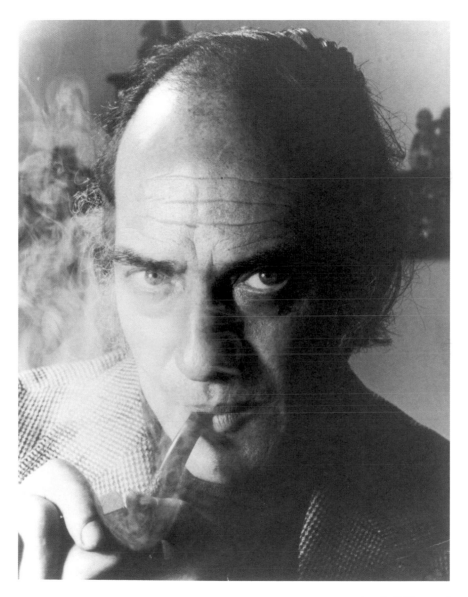

Leon Garfield, 1921–96
Unknown photographer, 1967
Bromide print, 241 x 193mm (9¹/₂ x 7⁵/₈")
Oxford University Press

RICHARD ADAMS

b.1920

ALTHOUGH Richard Adams wrote one of the best-selling books of the 1970s, he has no real claim to be remembered as a children's writer. Indeed, it is arguable whether *Watership Down* (1972) is any more a children's book than it is an adult book. Adams himself certainly did not intend it to be specifically for children, saying, 'I do not, myself, recognise the distinction between publications for children and for adults . . . In my view, the distinction may do more harm than good by deterring children from reading books which they would enjoy if left to themselves but which they have been told are "for adults".' This is, in effect, an echo of C.S. Lewis, who wrote, 'A book that is not worth reading when you're sixty is not worth reading when you're six'.

The origins of *Watership Down* lay in Adams's first-hand observation of rabbits and the stories he used to tell to his little girls. A manuscript of considerable length – far longer than the traditional children's book – it tells the adventures of a small band of rabbits who migrate to the Hampshire Downs to find a better place to live.

The publication of *Watership Down* exemplifies the quirky nature of the publishing business. Turned down by several major firms, it was finally accepted by the small independent company Rex Collings and almost instantly became a best seller, at one point holding the record for the highest sum paid for paperback rights. It has been translated into more than twenty languages and its mass success, both in Britain and the United States, was followed by its adaptation for an animated cartoon film (which included the hit single 'Bright Eyes' by Art Garfunkel). The book appeals to adults and children alike, with its evocation of the English countryside near Adams's home and its compelling narrative.

Adams was born and brought up in Berkshire, and was educated at Bradfield and at Worcester College, Oxford. After coming to London he worked for twenty-five years as a civil servant in the Ministry of Housing and Local Government and the Department of the Environment. He became a full-time writer in 1974 after the success of *Watership Down*, which won the Carnegie Medal and the *Guardian* Children's Book Prize. His other books include *Shardik* (1974), *The Plague Dogs* (1977), *The Girl in a Swing* (1980), *Maia* (1984), *The Bureaucats* (1985), *Traveller* (1988), *The Day Gone By* (an autobiography; 1990), *Tales from Watership Down* (1996) and *The Outlandish Knight* (2000).

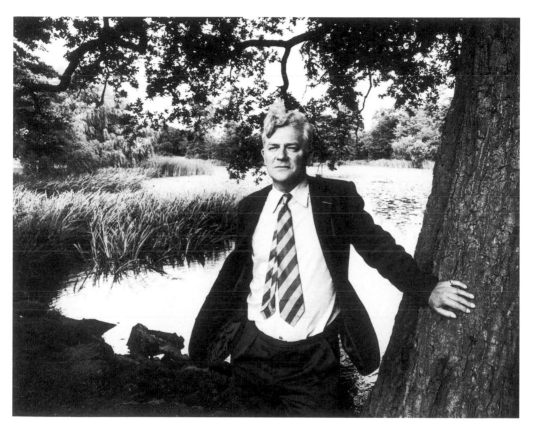

Richard Adams, b.1920
Mark Gerson, July 1974
Modern print from an original negative,
300 x 365mm (11³/₄ x 14³/₈")
National Portrait Gallery (NPG x88200)

NINA BAWDEN

b.1925

NINA Bawden is one of the small band of novelists who write with equal pleasure and success for adults and children. She was already an established adult novelist when, on finding a marked lack of books with social or emotional realism available for her own children, she decided to write such a book herself. Bawden feels it important to show real emotions in her stories: 'Children often feel guilty and jealous. Things that they may have done are things that frighten them greatly. I think I was a jealous, guilty child. I think a great many children are guilty and jealous and they're ashamed of these feelings, which is why it's quite sensible and interesting to write about them.' She remembers her own childhood clearly. This is partly because the Second World War was a watershed in her childhood, so there is a clear divide between the time 'before', when she lived an enclosed life in London with her mother and her brothers, and the period 'during', when she was evacuated to the Welsh Valleys, where she had to make a success of living among complete strangers. It is this experience that inspired Bawden's best-loved book *Carrie's War* (1973). All children are the helpless pawns of adults, but the evacuated child was particularly helpless – a theme that Bawden explores frequently in her books.

Bawden's first adult novel, *Who Calls the Tune* (1953), was published over ten years before her first children's book *The Secret Passage* (1964). Since then she has continued writing with vigour and commitment, publishing over forty books both for children and for adults, and has said, 'I consider my books for children as important as my adult work, and in some ways more challenging. The things I write about for adults, I write about for children, too: emotions, motives, the difficulties of being honest with oneself, the differences between what people say and what they really mean.' (Quoted in Jill Burridge and Michael Rosen, *Treasure Islands 2*, 1993.)

Initially, Bawden's children's books – *On the Run* (1964), *The White Horse Gang* (1966) and *A Handful of Thieves* (1967) – were largely dramatic adventure stories in which children, acting well within the true abilities of their age, play intelligent and convincing roles. After *Carrie's War* she wrote several others that showed children managing in unusual circumstances, most particularly *The Peppermint Pig* (1975), for which she won the *Guardian* Children's Book Prize. More recently, in *The Outside Child* (1989), *The Real Plato Jones* (1994) and *Off The Road* (1998), Bawden has written about how the past affects the present.

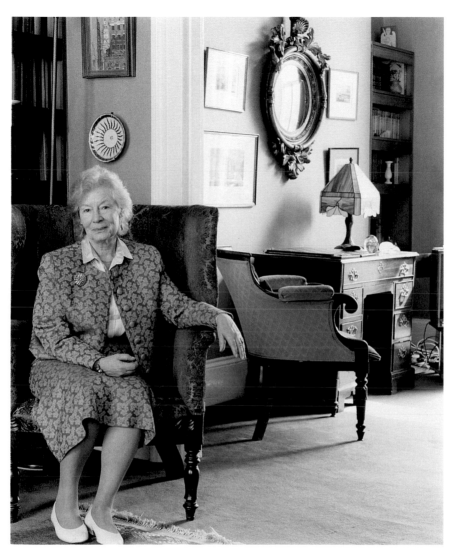

Nina Bawden, b.1925
David Bennett, 27 April 1994
Toned bromide print, 323 x 265mm (12³/₄ x 10³/₈")
National Portrait Gallery (NPG x45968)

JOSEPHINE, CHRISTINE and DIANA PULLEIN-THOMPSON

b.1924, b.1925, b.1925

THE Pullein-Thompson sisters – Josephine and the twins Christine and Diana – are an example of exceptionally effective family co-operation. The daughters of Joanna Cannan, herself a writer of pony stories, including *A Pony for Jean* (1936) and *They Bought Her a Pony* (1944), their writing careers began together with all three as co-authors of *It Began with Picotee* (1946). Written when Josephine was seventeen and the twins just sixteen, the book followed their mother's example, being a book that is as much about the owner as about the pony. Soundly based on a knowledgeable passion for horses, the Pullein-Thompsons' books are part gritty realism, depicting all the bumps and knocks that riding brings, and part wish-fulfilment, as the children, mostly girls, become better and wiser from what they have learnt from their animals.

Over the next fifty years the Pullein-Thompson sisters published more than 150 pony book adventure stories between them. Their attitude and their commitment to their writing can best be summed up by Diana's comment, 'My children's stories are written specifically for young people, not for book-buying parents or literary critics ... The most encouraging remark ever made to me by a fan is, "I love your books so much that I keep them on a shelf by my pillow".'

The Pullein-Thompson sisters certainly knew what they were writing about. Having inherited their love of horses from their mother, they set up and ran a riding school and were all active members of the Pony Club. Josephine was a Pony Club District Commissioner and instructing her readers about riding and caring for their horses lies at the heart of many of her stories, and especially the Pony Club series. She also became General Secretary and then President of the English centre of PEN, a world association of writers, work for which she was awarded an MBE in 1984. Christine, the most prolific of the three, has remained loyal to the pony story, although some of her stories for younger readers are not about horses, and has deliberately brought them up to date, as far as is possible. Diana branched out from pony stories, writing adult fiction and biography under her married name Diana Farr. The sisters' enormous output of dramatic and well-founded stories kept the pony story alive, providing an attractive fantasy world that remained constant as times changed.

After years of writing their own stories the sisters came together again as authors for the joint venture of writing sequels and 'prequels' to Anna Sewell's *Black Beauty* (1877) and to write their collective autobiography, *Fair Girls and Grey Horses* (1996).

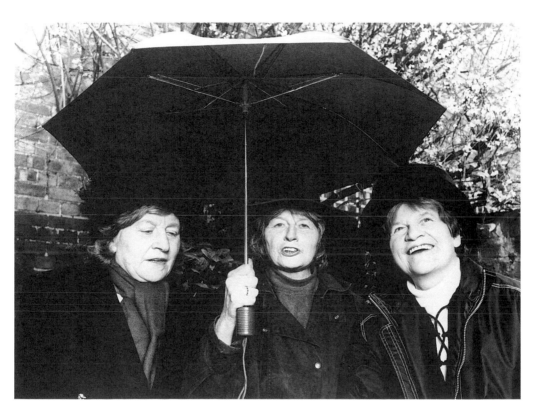

Christine Pullein-Thompson, b.1925 (left),
Diana Pullein-Thompson, b.1925 (centre),
and Josephine Pullein-Thompson, b.1924 (right)
Sam Barker, 1998
Bromide print, 230 x 305mm (9 x 12")
National Portrait Gallery (NPG x87719)

RAYMOND BRIGGS

b.1934

WERE Raymond Briggs only known for *The Snowman* (1979), and particularly the film of 1982 with its well-loved theme song, it would give the wrong impression. Briggs is by no means as sentimental or romantic as those images would suggest, and some of his picture books have an appeal that reaches far beyond the usual market for such books and are driven as much by political and social issues as by more traditional subjects.

The son of a milkman, Briggs has recorded many aspects of his childhood, including his father's job with the milk float (out delivering early in *Father Christmas*) and the terraced house in which he grew up. Briggs's books reflect both the working-class values of his childhood and the more radical views of his father, which are most specifically revealed in his portrait of his parents' marriage *Ethel & Ernest* (1998).

Although his first ambition had been to be a newspaper reporter, Briggs began drawing seriously at about thirteen and went to Wimbledon School of Art when he was fifteen. After two years of National Service he went to the Slade School of Fine Art in London, believing that the sophistication of the tutors and students would turn him into the famous painter that he had now decided to become. Instead, he left the Slade feeling that he had achieved nothing at all and convinced that he was not very good at painting.

Briggs began to do black-and-white line illustrations for children's books and then wrote a few stories himself. His first major achievement as an illustrator was his 897 illustrations for *The Mother Goose Treasury*, for which he won the Kate Greenaway Medal in 1966. His next success came with his affectionate but irreverent strip cartoon *Father Christmas* (1973), which won a second Kate Greenaway Medal. Briggs has always loved comic strips and cartoons, and from *Father Christmas* onwards he has developed the style – repulsively in *Fungus the Bogeyman* (1977), wordlessly in the glorious fantasy *The Snowman*, and to powerful political effect in *When the Wind Blows* (1982), which reflects his lifelong commitment to nuclear disarmament. *The Tin-Pot Foreign General and the Old Iron Woman* (1984) is a biting commentary on Britain's involvement in the Falklands War and, in particular, the role of Margaret Thatcher.

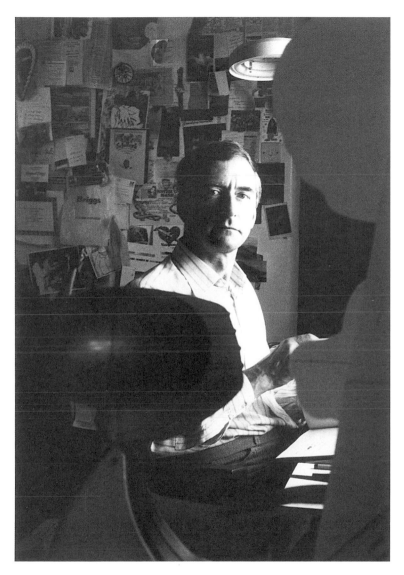

'WALKING in the Air', the theme tune from the animated 1982 film of *The Snowman*, originally sung by Peter Auty, became a chart-topping hit when sung by Welsh choir boy Aled Jones. The film has enjoyed Christmas viewing every year since its release and has also been adapted as a seasonal stage show. Briggs's image of the Snowman became universal in the 1990s as it was promoted on merchandise from puzzles to pyjamas. In a darker mood altogether, *When the Wind Blows* was adapted for the stage in 1989.

Raymond Briggs, b.1934
Duncan Fraser, 1982
Resin print, 260 x 177mm (10^{1}/$_{4}$ x 7")
National Portrait Gallery (NPG x20064)

JOAN AIKEN

b.1924

JOAN Aiken is the daughter of a writer – the American poet Conrad Aiken – and the step-daughter of another – the English novelist Martin Armstrong. So becoming a writer was something she almost took for granted. She writes extensively for adults and children and is equally at home with both, although noting differences between the two audiences.

> Adult books tend to be for entertainment. A lot of adults, if they read fiction, want to rest themselves and be entertained, whereas children, when they read, are really reading to learn about life unconsciously, or they should be, because reading is a tremendously important part of their experience.
> (Jill Burridge and Michael Rosen, *Treasure Islands 2*, 1993)

Aiken was encouraged to write her first children's story by her step-father, who had written a series for the rapidly expanding Children's Hour on BBC Radio. Inspired by his success, Aiken, who was only sixteen at the time, wrote her own story for Children's Hour, which was immediately accepted. It was the first of many collaborations Aiken formed with the BBC. One of her best known, *Arabel's Raven* (1972) and its sequels, the popular series about a young girl and her over-large and overbearing raven Mortimer, was written in response to a request for a series for the BBC Television children's programme *Jackanory*.

But Aiken's audience is not just confined to young listeners and viewers; she is even better known for her outstanding creation of an historical period that never existed – but could perhaps have done so. *The Wolves of Willoughby Chase* (1962), a dramatic gothic adventure, is set in a thickly wooded landscape inhabited by wolves. It is the nineteenth century and King James III is on the throne; the Hanoverians have never arrived and England is joined to France by a channel tunnel; America was long ago invaded by the Romans and some of its inhabitants still speak Latin.

The Wolves of Willoughby Chase received immediate acclaim and Aiken continued the series with other titles, including *The Whispering Mountain* (1968) for which she won the *Guardian* Children's Book Prize. The books include such memorable characters as the cockney heroine Dido Twite and the wicked governess Miss Slighcarp. In both setting and characters the influence of Charles Dickens is clear, for which Aiken credits her mother who read his books aloud to her.

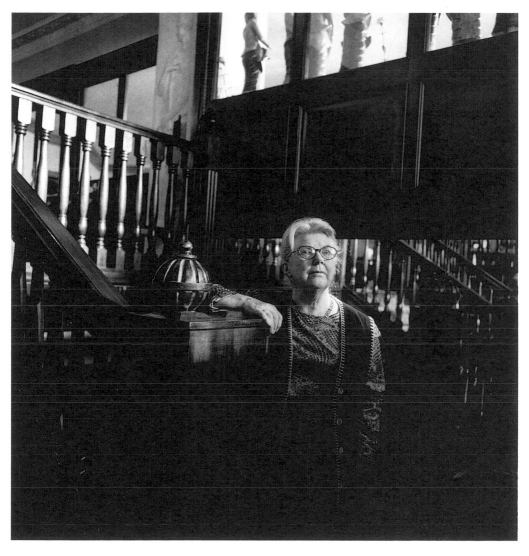

Joan Aiken, b.1924
Beth Gwinn, 1997
Bromide print, 397 x 396mm (15⁵/8 x 15⁵/8")
Courtesy of the photographer

1980s &1990s

Children's writing at the end of the century successfully embraced social realism. At the same time, the publishing phenomenon of Harry Potter proved that the traditional themes of fantasy and make-believe still have the power to attract new readers and bridge the gap between young and old.

J.K. ROWLING

b.1965

J.K. ROWLING has caused a sensation in children's book publishing with her creation of the boy wizard Harry Potter and his magical world at the Hogwarts School for Witchcraft and Wizardry. Part school story, part fantasy, part adventure, *Harry Potter and the Philosopher's Stone* made an immediate impact when it was published in 1997. Within just a few months of publication the book had become a best seller and Rowling had become an international celebrity.

Joanne Kathleen Rowling – her first names were reduced to initials to attract readers of both sexes – grew up in Chepstow in Gwent. The elder of two sisters, she enjoyed playing imaginary games and invented stories that she told to her younger sister, a habit she continued with school friends. Rowling was brought up in a house full of books, including Kenneth Grahame's *The Wind in the Willows*, which her father read to her when she was ill with measles. She wrote her own first story, called 'Rabbit', when she was six and was also an avid reader herself, her favourite book from childhood being Elizabeth Goudge's *The Little White Horse* (1946).

Rowling studied French and Classics at Exeter University, spending a year of the course in Paris teaching English as a foreign language, and then worked for Amnesty International in London. She began writing when she was working; in her lunch hours she wrote short stories and then an adult novel, scribbling in cafés where she found the peace to write freely. It was not until the idea for Harry Potter came to her in 1990 that she thought of writing for children. Rowling has claimed that Harry 'strolled into my head fully formed'. From the beginning she planned an ambitious seven-book series – one for each of the years that Harry would spend at his wizard school. From that moment on, she made detailed plans of the books and kept boxes full of notes about ideas, names and the construction of her imaginary world.

Having the idea alone did not enable Rowling to give up work and write. She moved to Oporto in Portugal, where she returned to teaching English as a foreign language. While in Portugal, Rowling married and her daughter Jessica

Harry Potter and the Philosopher's Stone
(children's cover)
By J.K. Rowling (Bloomsbury, 1997)
Courtesy of Bloomsbury

Harry Potter and the Philosopher's Stone (adult's cover)
Courtesy of Bloomsbury

was born. The marriage failed and soon after Jessica's birth Rowling moved to Edinburgh, bringing with her the first three chapters (almost exactly as they were published) and the draft of much of the rest of the first Harry Potter story.

It was in Edinburgh, sitting writing in a café while Jessica slept beside her, that Rowling finished *Harry Potter and the Philosopher's Stone*. Twice as long as was thought 'usual' for a children's novel at the time, the book was turned down on those grounds, but Rowling persevered and finally found both an agent and a publisher. Her success came unusually quickly for a children's book author. Within a year *Harry Potter* had won the Smarties Prize and the Children's Book Award and had been nominated for other major awards, including the Carnegie Medal. Rowling was already writing the second story despite the considerable demands that success made on her time, especially in the United States, where her reputation grew even more quickly than in Britain.

With the publication of the second title, *Harry Potter and the Chamber of Secrets* (1998), Rowling showed that she could sustain and develop Harry and Hogwarts, while in the third, *Harry Potter and the Prisoner of Azkaban* (1999), she added darkness and depth to the magical formula. With each title her stature increased and the publication of the fourth, *Harry Potter and the Goblet of Fire* (2000), was greeted with an explosion of media attention. Rowling became a superstar. Her success is unprecedented for a children's author: she is popular with readers of all ages – her books remaining week after week on the best-seller lists for adults and children alike – and her particular blend of tradition and fantasy, laced with humour, has attracted readers all over the world. Rowling has handled the exceptional publicity with dignity and discretion. She remains available and loyal to her key audience, the children who read her books, who flock to hear her speak and who write to her in such quantities, but otherwise she keeps herself as private as possible, determined to deliver the remaining titles of the seven she has promised.

FOLLOWING the precedent laid down by the books, the film version of *Harry Potter and the Philosopher's Stone*, released in November 2001, immediately broke all box-office records.

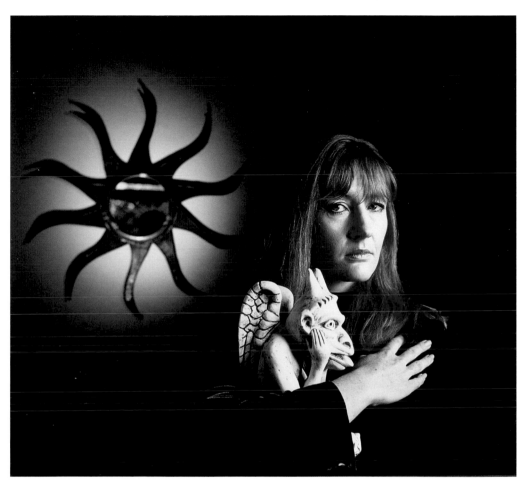

J.K. (Joanne Kathleen) Rowling, b.1965
Murdo MacLeod, November 1998
Cibachrome print, 395 x 395mm (15^1/$_2$ x 15^1/$_2$")
National Portrait Gallery (NPG x88402)

QUENTIN BLAKE

b.1932

IN 1999 Quentin Blake was appointed the first Children's Laureate, in honour of his lifetime's contribution to children's books. Through his illustrations Blake has been influential in interpreting other authors' stories and also in creating his own picture books. In Blake's work as Children's Laureate he embarked on many new projects designed to bring children and drawing closer together, including the curatorship of the *Tell Me a Picture* exhibition at the National Gallery, London, in 2001.

Blake was born in London and dates his great interest in drawing from the age of about nine or ten, when he realised he had a talent for it. While still at school, he had his first cartoon published in *Punch*, the leading satirical magazine of the day; it was the start of a forty-year association with the magazine. After National Service he went to Downing College, Cambridge, where he read English. He followed his degree by training to be a teacher.

Throughout his time at Cambridge and in the following years, Blake continued to have his work published. He produced covers for both *Punch* and the *Spectator*, and also for several Penguin books, including Kingsley Amis's *Lucky Jim* (1954). He taught at the Royal College of Art for many years and was Head of Illustration from 1978 to 1986. Blake realised that the opportunity to illustrate a whole story lay within children's books, but he needed a story before he could begin. It was his friend John Yeoman who wrote *A Drink of Water* (1960) for him, a story full of humans and animals that provided exactly the scope Blake needed. It was the beginning of a partnership on many books, including most recently *The Heron and the Crane* (1999).

Blake's apparently effortless spontaneous style, with its scant but angular and energetic lines providing every effect, has changed little over the years. His picture books include *Patrick* (1968), the first book of which he was both author and illustrator, *Mr Magnolia* (1980), which won the Kate Greenaway Medal, and more recently his wordless picture book *Clown* (1995). Blake is an excellent collaborative illustrator, too, and has had several long-standing partnerships with writers, including among others, Russell Hoban, Michael Rosen and Joan Aiken. But he is best known for his partnership with Roald Dahl. Blake proved to be the perfect illustrator for Dahl's work, and Dahl's stories are now forever linked with Blake's realisation of them in much-loved – and hated – characters such as the giant in *The BFG* (1982), the loathsome grand witch in *The Witches* (1983) and the terrifying Miss Trunchbull in *Matilda* (1988). Blake was awarded the OBE in 1988.

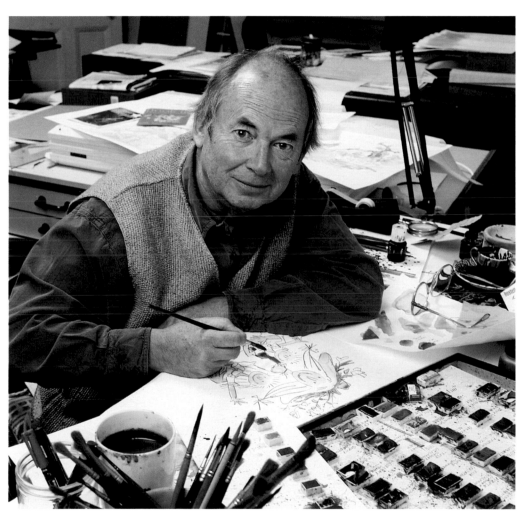

Quentin Blake, b.1932
Jason Bell, 28 August 1998
C-type colour print, 397 x 394mm (15⁵/₈ x 15¹/₂")
National Portrait Gallery (NPG x125005)

MICHAEL ROSEN

b.1946

MICHAEL Rosen's contribution to children's books is wide ranging. For children themselves, he is a poet, storyteller and performer, but he is also an informed commentator and broadcaster on writing for children.

Rosen was brought up in Harrow. Both his parents were involved in teaching English. He wrote a couple of plays for adults while at Oxford University, but since then his writing has mostly been for children. His poetry was first published in 1974 when, along with Gareth Owen, Kit Wright and others, he wrote original poetry (which he called 'stuff') following American poets such as Carl Sandburg (1878–1967) and e.e. cummings (1894–1962). Rosen's first collection *Mind Your Own Business* (1974), with illustrations by Quentin Blake, was quickly followed by four others, including *You Can't Catch Me!* (1981), which won the Signal Poetry Award.

Much of the strength of Rosen's poetry comes from the immediacy of its subject matter: Rosen draws extensively on his own experiences both as a child – with tellingly accurate observations on being a younger brother – and as a parent, capturing the obsessive and often illogical behaviour of adults and children. Rosen has a broadly benign view of families, which allows him to point out foibles and pitfalls with indulgence. But he also makes considered social and political points through his poems and through the different forms – playground rhymes, rap and blank verse – in which he writes.

After the success of his first collections, Rosen has written extensively for all ages: picture book texts such as *We're Going on a Bear Hunt* (1989), illustrated by Helen Oxenbury, which won the Smarties Prize, and collections for older readers such as *When Did You Last Wash your Feet?* (1986) and *Mind the Gap* (1992). He has written fiction – *The Bakerloo Flea* (1979) and *Nasty!* (1982) – as well as re-tellings, as in *The Wicked Tricks of Till Owlyglass* (1989). Rosen presented the children's book programme *Treasure Islands* for BBC Radio Four from 1991 to 1998 and is a frequent broadcaster on language and literature. He won the Eleanor Farjeon Award in 1997 for his outstanding contribution to children's books.

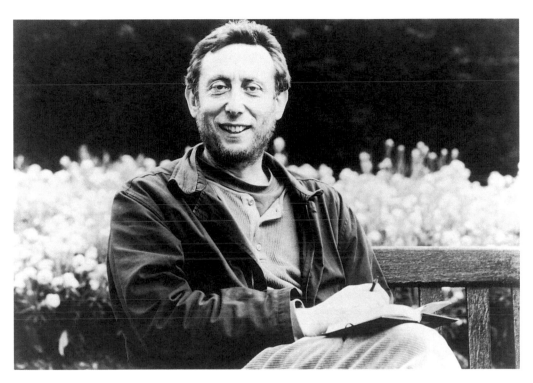

Michael Rosen, b.1946
Martin Salter, 1995
Bromide copy print, 366 x 494mm (14³/8 x 19¹/2")
Courtesy of Penguin

DICK KING-SMITH

b.1922

FOR Dick King-Smith, writing is a third career – one he started only when he was in his mid-fifties. The origins of its success lie in his previous careers: his knowledge of animals comes from farming, while his interest in writing for children comes from his time as a primary-school teacher.

King-Smith was born into a comfortably-off family in the West Country. From his childhood he had a passion for animals. He kept and bred budgerigars as well as owning rabbits, tortoises, mice and rats, and always wanted to become a farmer. The family business, a paper mill, owned a farm and King-Smith took up the running of it. He was not required to make a profit, merely to supply the mill with milk and eggs. As a result, he kept animals that appealed to him, rather than managing the place as a profitable business. He had a mixed herd of cows, a few goats and, above all, pigs – his favourite animals.

When the farm failed, King-Smith decided to train as a teacher and took up his first post at a small village primary school when he was over fifty. Stimulated by his pupils, King-Smith began to write. Inspiration came from his love of such stories as Kenneth Grahame's *The Wind in the Willows*, in which the notion of talking animals is accepted unquestioningly. King-Smith also drew on his farming experiences to give his animal characters a convincing reality. The result was his first book *The Fox Busters* (1978), a classically constructed story of how the weak overcome the strong by cunning, in this case how the chickens take their revenge on the predatory foxes.

King-Smith's first major success came with his sixth book *The Sheep-Pig* (1983), which won the *Guardian* Children's Book Prize and, a decade later, was translated into the box-office hit *Babe*. His popularity as an author led to work as a television presenter in which his animals, especially his dog Dodo, played starring roles. Since then he has published over 100 titles for children, the majority of which are a witty mixture of animal reality and audacious fantasy.

THE Oscar-winning film *Babe* (1995), with its Australian setting and its farmyard of magical animals, was a brilliant interpretation of King-Smith's book *The Sheep-Pig*. Unusually for an author he was delighted with the film version, writing, 'It was soon plain to us that the adaptation from the book had been wonderfully well done'. *The Queen's Nose* was loosely adapted for a long television series in the late 1990s.

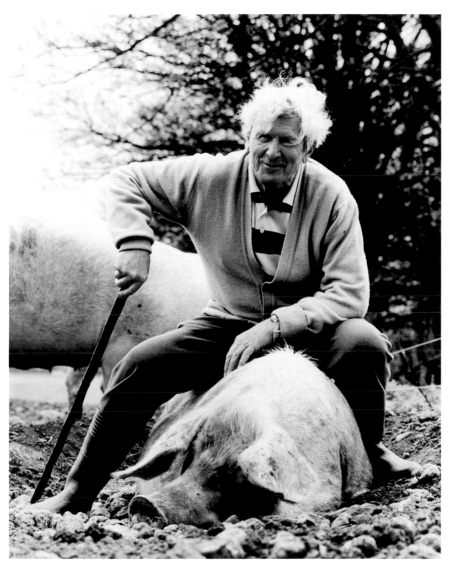

Dick King-Smith, b.1922
Michael Dyer, April 1991
C-type colour print, 286 x 230mm (11¹/₄ x 9¹/₂")
National Portrait Gallery (NPG x87184)

JANET and ALLAN AHLBERG
1944–94, b.1938

JANET and Allan Ahlberg have been one of the most successful artist and author partnerships. Their books, including *Each Peach Pear Plum* (1978), *Peepo!* (1981), *The Baby's Catalogue* (1982) and *The Jolly Postman* (1986), have all, in different ways, stretched the appeal of picture books, often by making original reuse of familiar fairy tales, a hallmark of the Ahlbergs' work. The Ahlbergs created many books before Janet's death in 1994. They defined their work as 'book making' rather than as the teaming up of an author (Allan) and illustrator (Janet), and they saw the project as a whole, caring about the use of the right paper and the type-face – the physical qualities of the book.

The couple met when both were training to be teachers. Janet swiftly decided to concentrate on her own art and design rather than on teaching, but Allan was a primary school teacher for ten years – a job that provided him with his close knowledge of the daily workings of the classroom – before they produced their first book, *Here Are the Brick Street Boys* (1975). The impetus for the book came from Janet, who wanted a story to illustrate. Allan drew on his classroom experience and produced a story about a group of children in an inner-city primary school. The real experiences of children in school is a theme that Allan returned to again and again in different ways, particularly with his poetry collections *Please Mrs Butler* (1983) and *Heard it in the Playground* (1989).

Janet, Allan and Jessica Ahlberg
Illustration by Janet Ahlberg from *Peepo!* (Penguin, 1981) Courtesy of Allan Ahlberg

The Ahlbergs' subsequent projects were developed in other ways. Allan's account of how they worked is 'One of us gets an idea that we like the sound of, talks to the other about it. And we bat it around then, like table tennis.' Interviewed at the same time, Janet said the original idea was usually Allan's – often it came to him while out running. 'He comes back in, dripping, and rushes for a little scrap of paper and a pencil. I start to speak to him and he says, "Just a minute", usually because he wants to write down what he's thought of.' (Quoted in Jill Burridge and Michael Rosen, *Treasure Islands 2*, 1993.)

Where originally the Ahlbergs had drawn extensively on Allan's teaching experience, they moved towards more family-based stories in *Peepo!*, with its cosy, domestic setting, and especially in *The Baby's Catalogue*, which was a creative response to the endless delight their daughter Jessica had in poring over mail-order catalogues.

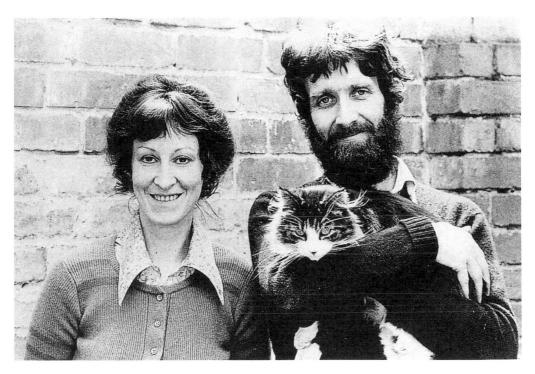

Janet, 1944–94, and Allan Ahlberg, b.1938
Glyn Williams, 1976
Bromide print, 272 x 406mm (10³/₄ x 16")
Courtesy of the photographer

Allan's output was always more than one illustrator could manage, so he has collaborated with other illustrators and has continued to write picture books, poetry and fiction since Janet's death, including, in 2001, *Friendly Matches* with Fritz Wegner and *The Adventures of Bert* with Raymond Briggs.

ANNE FINE

b.1947

ANNE Fine's hero is Andrew Carnegie, the founder of the public library system. Without him, and them, Fine would never have found the endless supply of books that she devoured as a child and adult.

Born the second of five sisters, the younger three being triplets, Fine cannot remember not being able to read and spent much of her childhood reading – moving from the children's library to the adult library as soon as she was able. Favourite authors included Enid Blyton, Anthony Buckeridge and, above all, Richmal Crompton. Fine worked briefly as a teacher, first in a school and later in a prison, before becoming an information officer for the charity Oxfam.

Fine married and lived in the United States for several years and then settled in Edinburgh with her two children. It was her inability to get to the library during a blizzard that propelled her into writing her first book; instead of reading, she set to and wrote *The Summer House Loon* (1978). Fine's first book brought a fresh voice to adolescents, just one of the audiences for whom she writes. She has an ability to be funny about deeply unfunny subjects, most particularly the general problems of adolescence and the specific problems of family break-up. She has a marked ability to write from a teenager's point of view, understanding the difficulties but 'trying to show that the battle through the chaos and confusions is worthwhile and can, at times, be seen as very funny'.

Fine writes for adults as well as children of all ages, but it is in her books for teenagers that she has been most innovative. Her humorous but poignant *Madame Doubtfire* (1987), later filmed as *Mrs Doubtfire*, was one of the first of the black comedies about divorced families, and her ground-breaking *The Tulip Touch* (1996) explored the notion of evil in children at a time when there was a nationwide analysis of the subject during the trial of two young boys for the murder of two-year-old James Bulger.

In her books for younger children Fine also tackles serious subjects with humour, such as gender issues in *Bill's New Frock* (1989), the value of silence in *Loudmouth Louis* (1998) and in *Charm School* (1999), in which she reflects on the dubious qualities that are thought of as the prerequisites of femininity.

Fine has won more literary prizes than any other living children's writer, including the Whitbread Children's Novel Award and the Carnegie Medal, both twice over, and the *Guardian* Children's Book Prize. She was the UK nominee for the Hans Christian Andersen Author Award and succeeded Quentin Blake as Children's Laureate in 2001.

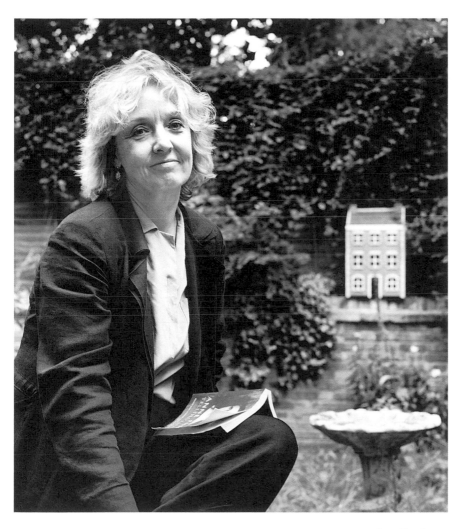

Anne Fine, b.1947
Cinnamon Heathcote-Drury, August 2001
Bromide fibre print, 538 x 485mm (21¹/₈ x 19¹/₈")
National Portrait Gallery (NPG x125023)

SHIRLEY HUGHES

b.1927

SHIRLEY Hughes grew up on the outskirts of Liverpool where she spent hours sketching, drawing and writing stories and plays with her two sisters. From early on she was influenced by the illustrations of E.H. Shepard (1879–1976) and William Heath Robinson (1872–1944) and by comics, especially those left behind by the American GIs who were based in England during the Second World War.

Hughes studied costume design at Liverpool College of Art and then moved to the Ruskin School of Fine Art, Oxford. After a vacation job helping behind the scenes at Birmingham Repertory Theatre, she decided that the world of stage was not for her and began to concentrate on book illustration, developing a skill that was underpinned by an invaluable background in life drawing.

Initially, Hughes illustrated books by other people: Dorothy Edwards's *When My Naughty Little Sister Was Good* (1968) and the many subsequent stories about her are inseparable from Hughes's illustrations; Noel Streatfeild's Bell Family stories were all illustrated by Shirley Hughes; and there are hundreds of other stories for which she drew the pictures. With three children of her own, Hughes's close observation of children – she carries a sketchbook everywhere – translated through her distinctive line drawings that make children attractively wholesome without being sentimental, have added a vital dimension to stories for readers of all ages.

Later, Hughes turned to creating her own picture books and to developing her increasingly robust style. Her intimate knowledge of domestic life enabled her to tackle the changing modes of parenting and childcare in stories such as *Helpers* (1975; *George and the Babysitter* in the US), for which she won the Other Award – an award given in recognition of a book that reflects the way in which contemporary society is changing – as well as in such reassuring picture books as *Dogger* (1977), which won the Kate Greenaway Medal. Her most enduring characters Alfie and his little sister Annie Rose have appeared in many titles since *Alfie Gets in First* (1981). Exactly capturing the small-scale details of the lives of young children, they create an intimate picture of childhood. Hughes has also created stories by using pictures in different ways – in pictures alone, as in the wordless *Up and Up* (1979), and through the use of comic strip, as in *Chips and Jessie* (1985), an original attempt to help young readers move from pictures to words.

Shirley Hughes's contribution to children's visual delight and understanding was celebrated by her winning the Eleanor Farjeon Award in 1984 and by her OBE in 1989.

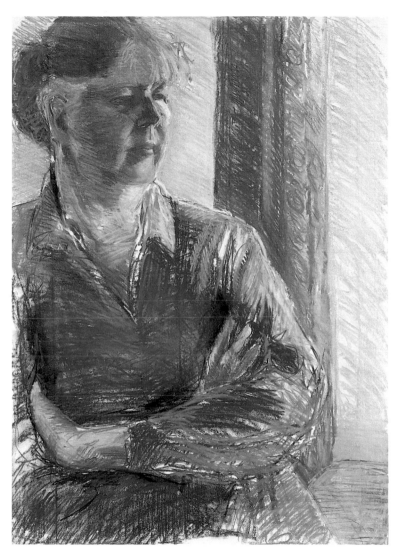

Shirley Hughes, b.1927
Clara Vulliamy, Shirley Hughes's daughter, 1981
Pastel on paper, 770 x 550mm (30³/8 x 21⁵/8")
Courtesy of Shirley Hughes

MICHAEL MORPURGO
b.1943

MICHAEL Morpurgo's own experience of being sent off to preparatory school, with the attendant problems of adapting to being away from home and living in a community without any privacy, is a theme he returns to several times in his books, most obviously in *The War of Jenkins' Ear* (1993) and *The Butterfly Lion* (1996). Morpurgo found reading a considerable comfort at school, and the books of G.A. Henty (1832–1902), C.S. Forester (1899–1966) and, especially, Robert Louis Stevenson (1850–94) were very important to him. Stevenson's *Treasure Island* (1883) has remained his favourite book from childhood and was the inspiration for his own 'treasure island' story *Kensuke's Kingdom* (1999).

On leaving school, Morpurgo went briefly to the Royal Military Academy, Sandhurst. He then trained as a primary school teacher and it was while he was teaching that Morpurgo began to write. 'I was inspired by the wonderfully fresh, spontaneous, positive way the children reacted to the books I read to them in class. It made *me* read a lot more, and gradually I started to write my own stories.' (Quoted in *An Interview with Michael Morpurgo*, 1994.)

Although he enjoyed teaching and the close association with children, Morpurgo felt that there was a limit to the good that even a teacher could do in school. Instead, he founded Farms for City Children with his wife Clare, who had also trained as a teacher. Based in a North Devon farm, and now extended to two other farms, it is a project that brings groups of children from inner-city schools to the countryside for a week at a time, where they play an active part in the daily life at the farm. The children are also the audience for his new stories, as Thursday night on the farm is story night.

Morpurgo has written many books, including *Conker* (1987), *Colly's Barn* (1991) and *Sam's Duck* (1996), which have been inspired by the farm and the effect it has on the children who visit it. He is a prolific and prize-winning author of books for children of all ages, gathering ideas for his stories from a wide range of sources, including real events such as in *The Wreck of the Zanzibar* (1995), a story of life on the Isles of Scilly, and *Out of the Ashes* (2001), a diary of the outbreak of foot-and-mouth disease in Britain. He has also written new versions of such classic stories as Joan of Arc, King Arthur and Robin Hood. Morpurgo writes at home on the farm, outside in the garden in good weather or lying in his bed wearing thick woolly socks when it is cold and wet.

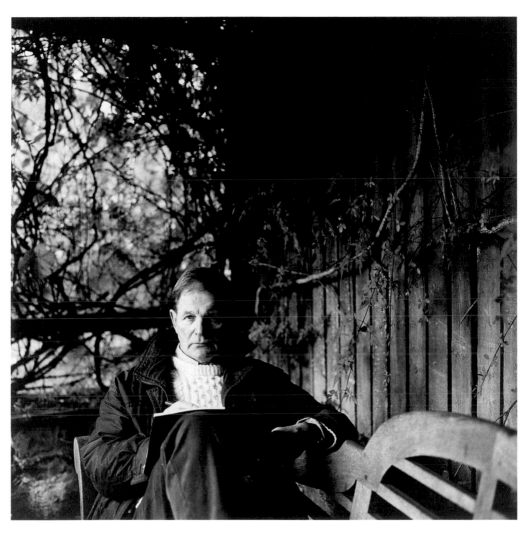

Michael Morpurgo, b.1943
Cinnamon Heathcote-Drury, October 2001
C-type colour print, 406 x 406mm (16 x 16")
National Portrait Gallery (NPG x125037)

PARTNERS John Agard and Grace Nichols both write their own poetry but also work together on books such as *A Caribbean Dozen* (1994), an introduction to thirteen Caribbean poets, and co-wrote a collection of Caribbean nursery rhymes *No Hickory No Dickory No Dock* (1991).

JOHN AGARD was born in Guyana. His entirely English education, received against a background of Caribbean culture, enables him to write in standard English or Creole with equal comfort and vigour and he switches between the two, to achieve the best effect. He began writing poetry when he was at school, inspired by a love of words picked up partly from an English teacher who introduced him to British humour through such writers as P.G. Wodehouse and Jerome K. Jerome, whose book *Three Men in a Boat* (1889) Agard adored, and partly from listening to the descriptive cricket commentaries on BBC Radio.

Agard came to England in 1977 and published his first book for children *Letters for Lettie, and Other Stories* just two years later. He has published poetry collections, such as *I Din Do Nuttin* (1983), *Say It Again, Granny!* (1986) and *Laughter is an Egg* (1990), and has also written brief poetic texts for picture books. His collection *We Animals Would Like a Word With You* (1996) was shortlisted for the Kurt Maschler Award and won a Smarties Prize. He has also written children's plays and adult poetry collections such as *From the Devil's Pulpit* (1997) and received the Paul Hamlyn Award for Poetry. His most recent collection for children is *Come Back to Me My Boomerang* (2001).

Agard has worked for the Commonwealth Institute, promoting Caribbean culture, and was poet in residence at the South Bank Centre, London, before being appointed the first poet in residence at the BBC in 1998.

GRACE NICHOLS was brought up in a seaside village in Guyana and she drew on the native wildlife for her inspiration. She proudly calls herself 'a Caribbean person', explaining that the variety of races and cultures that makes up Caribbean people gives them a mixed identity which makes them citizens of the world.

With no television for entertainment, the social events of Nichols's childhood revolved around storytelling, something she has loved ever since. As a child she was enchanted by the Guyanese 'jumbie' – ghost – stories, which were full of local mythology and superstition. Like Agard, Nichols has inherited both Creole and English and

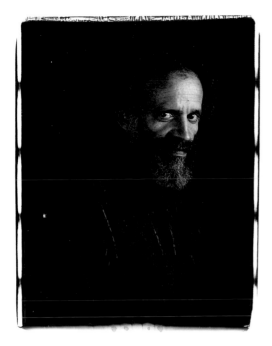

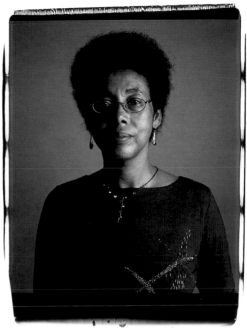

John Agard, b.1949
Maud Sulter, October 2001
Colour polaroid photograph, 828 x 560mm (32 5/8 x 22 ")
National Portrait Gallery (NPG P949(1))

Grace Nichols, b.1950
Maud Sulter, October 2001
Colour polaroid photograph, 823 x 560mm (32 3/8 x 22 ")
National Portrait Gallery (NPG P949(5))

she uses Creole in her writing 'not simply to preserve it, but also because it is vibrant, exciting and alive'.

Nichols worked as a journalist and reporter in Guyana before moving to Britain in 1977. She won the Commonwealth Poetry Prize in 1983 for her first book of adult poems *I is a long-memoried woman,* charting Afro-Caribbean history from the perspective of a woman and her struggle for emancipation. Her books for children include collections of short stories, such as *Trust You Wriggly* (1980) and *Leslyn in London* (1984), and poetry collections, including *Come On Into My Tropical Garden* (1988), *Give Yourself a Hug* (1994) and more recently *The Poet Cat* (2000). She was poet in residence at the Tate Gallery, London, from 1999 to 2000, and received a Cholmondley Award in 2001.

JACQUELINE WILSON

b.1945

AS an only child, Jacqueline Wilson spent much of her childhood creating her own companions by snipping out figures from dressmakers' paper patterns and turning them into imaginary playmates. Mostly girls, these 'friends' had their fair share of problems but in her stories Wilson allowed them to cope by escaping into the inner worlds of their own imagination. For these early playmates Wilson told and wrote stories, and she spent her pocket money on notebooks and pens. The first complete book she wrote, a story called 'The Maggots', was loosely based on Eve Garnett's *The Family From One End Street* (1937), which she had just read. Wilson was never in any doubt that she wanted to be a writer, although it was an ambition she kept secret in case it was scorned.

Brought up in and around Kingston in Surrey, where she still lives, Wilson left school and went to work as a journalist in Dundee. When only seventeen, she provided some of the inspiration – and the name – for D.C. Thompson's magazine venture into the teenage market *Jackie*. Wilson married at nineteen and returned to Kingston where, in addition to freelance journalism, she wrote her first book *Ricky's Birthday* (1973) – an easy reader for children – swiftly followed by five adult crime novels. In the early 1980s Wilson switched to writing for children, producing fifteen books in just six years, including six novels touching on contemporary teenage problems. These early forerunners of her current writing were longer, darker and more complex but imbued with the same understanding of adolescent anxieties.

Wilson's success came in the 1990s, when she began writing in a direct, easy-to-read, style designed for eight to twelve-year-olds. Tackling contemporary issues in a chatty and humorous manner, entirely without didacticism, Wilson has an unerring understanding of the feelings of young adolescents, especially those on the fringes of society. In addition to stories on the familiar 1990s territory of family break-up and divorce, Wilson has written thoughtfully about mental illness in *The Illustrated Mum* (1999), for which she won the *Guardian* Children's Book Prize, and about the death of a school friend in *Vicky Angel* (2000).

Wilson maintains her high standards despite a prodigious output: she produces three or four books a year, still written in pencil into a notebook, writing whenever and wherever she can.

Jacqueline Wilson, b.1945
Maud Sulter, October 2001
Colour polaroid photograph, 806 x 560mm (31³/₄ x 22")
National Portrait Gallery (NPG P949(6))

MALORIE BLACKMAN
b.1962

MALORIE Blackman lives in South London where she was born and grew up. One of five siblings with Barbadian parents, Blackman has always been aware of the two cultures from which she comes, an awareness that has inspired her writing. Blackman travelled the world working as a database manager for the news agency Reuters before she decided to take up acting. This was not a success. Instead, encouraged by creative writing classes, Blackman began to write.

From the beginning, Blackman intended to write for children and felt she had a mission. As a child she had been aware of the lack of stories for and about black children, a view confirmed when she began working as a Voluntary Reading Helper in schools. She intended her writing to normalise black children in books, giving them active and worthwhile roles and affirming their position in society.

Some of Blackman's first stories drew on her mother's experience of growing up in Barbados (a place she had not then visited). Set in the Caribbean, the Betsey Biggalow stories for younger readers are the everyday comings and goings of an ordinary little girl. In her novels, such as *Hacker* (1992), for which she won the W.H. Smith Mind Boggling Books Award, and *Operation Gadgetman!* (1994), Blackman made use of her first-hand knowledge of computers to write thrillers with a technological background. In both books the principal characters are black, and Blackman made sure that the families were shown as integrated, valuable members of society: in *Hacker* Vicky's father works in a bank; in *Operation Gadgetman!* Beans's father is an inventor. More recently, in *Noughts and Crosses* (2001), Blackman has explored racial prejudice by creating a world in which the race stereotypes are reversed.

Although Blackman is determined to correct racial imbalance in her books, she is also a dramatic storyteller, believing that stories empower young readers to achieve. Her adventures are exciting and ethical, nowhere more so than in *Pig-heart Boy* (1997), a thoughtful, well-researched story about the issues surrounding organ transplants that was shortlisted for the Carnegie Medal in 1999.

Malorie Blackman, b.1962
Maud Sulter, October 2001
Colour polaroid photograph,
819 x 560mm (32¹/₄ x 22")
National Portrait Gallery
(NPG P949(2))

PIG-HEART Boy, the poignant story of a young child whose life depends on the success of a transplant operation, became a BAFTA award-winning television series in 2000.

PHILIP PULLMAN

b.1946

PHILIP Pullman had a peripatetic early childhood that included living in Zimbabwe and Australia before settling in North Wales as both his father, who died when he was seven, and his stepfather worked for the RAF. Pullman went to Exeter College, Oxford, to read English. Knowing little about what it took to write a novel, he began his first on the morning after he had finished his Finals examinations, misguidedly confident that he would complete it within a few weeks. Although he did not manage to do so, Pullman continued, keeping to a strict regime of writing three pages a day, which he has maintained ever since.

Pullman trained as a teacher and taught for twenty-three years, first in a school and later training teachers. His teaching was passionate, if not formal, with much time devoted to storytelling – especially his re-tellings of Homer's *Iliad* and *Odyssey*. Pullman's first book, an adult novel, was written for a competition – it won shared first prize but remained unknown and thereafter he turned to writing plays for the schools where he was teaching. Many of these – such as *The Ruby in the Smoke* and *Count Karlstein* – were the forerunners of his later novels of the same titles (published in 1988 and 1991 respectively). Through these plays, Pullman perfected an ability to write for two audiences: the students who performed them and the parents who came to watch.

Pullman's books include the graphic novels *Spring-heeled Jack* (1989) and *Count Karlstein*, the Sally Lockhart quartet – a series of historical thrillers – two teenage novels, and books for younger readers such as *Clockwork* (1996), *The Firework Maker's Daughter* (1997) and *I Was a Rat!* (1999). He is best known for the trilogy *His Dark Materials*, consisting of *Northern Lights* (1995), which won both the Carnegie Medal and the *Guardian* Children's Book Prize, *The Subtle Knife* (1997) and *The Amber Spyglass* (2000). Through it, Pullman achieved the rare distinction of writing a children's book that had as much success with adults as with children. *The Amber Spyglass* received the unprecedented status for a children's book of being first longlisted for the 2001 Booker Prize and then winning the 2001 Whitbread Book of the Year Award.

The inspiration for the trilogy *His Dark Materials* came from a wide range of literary sources, but perhaps the most important influences were Samuel Taylor Coleridge's *Rime of the Ancient Mariner*, which Pullman first heard when he was eight and, above all, Milton's *Paradise Lost*, which he studied at school, its legacy remaining undeveloped until he realised that he wanted to write his own, quite different version.

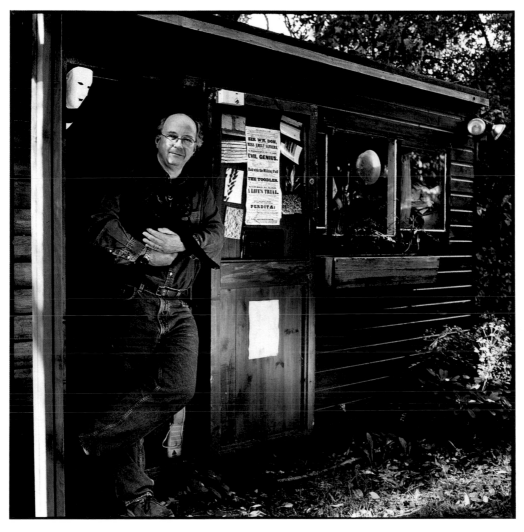

Philip Pullman, b.1946, and his pug dog Hogarth
Eamonn McCabe, October 2001
C-type colour print, 355 x 355mm (14 x 14")
National Portrait Gallery (NPG P958)

PULLMAN writes in a shed at the bottom of his garden, as shown here, where he has uninterrupted peace. It is warm and chaotic, crammed with books and manuscripts and post-it notes. He writes by hand on lined paper. Pullman sees his writing as a craft and the method of doing it is an important part of the process.

BENJAMIN ZEPHANIAH

b.1958

BORN in Coleshill, just outside Birmingham, Benjamin Zephaniah spent his early years living in Handsworth in the heart of the Jamaican community, steeped in Jamaican culture and, especially, Jamaican music. It provided a deep sense of belonging, which was shattered when Zephaniah and his family moved to an all-white area of Birmingham where he had his first experiences of racism and was himself attacked. Because of this, Zephaniah's mother moved the family away but Zephaniah had already been influenced by what he had seen and experienced.

The family were not great readers, although Zephaniah was brought up with a good knowledge of the Bible, especially the poetry of the Psalms. A bigger influence came from the oral poetry of Jamaica that he heard on tape. Unsuccessful in written work at school on account of his dyslexia, Zephaniah expressed himself instead through rap, poetry and rhyme. By the time he was fifteen he had become a performance poet with a large following, especially in schools. Jamaican music and oral poetry shaped the dub poetry that he began to write, but he also branched out, writing plays for stage, radio and television.

In the early 1980s Zephaniah moved to London, where he attracted huge audiences for his dub and rap performances. Writing down the poetry came later and the transition was difficult: Zephaniah spells his poems the way they sound, which makes them easy for other dyslexics to read. After the success of his poetry collections *Talking Turkeys* (1994), *Funky Chickens* (1996) and *School's Out* (1997), Zephaniah turned to writing fiction. *Face* (1999), the story of a boy whose face has to be rebuilt after an accident, explores the experience of prejudice; *Refugee Boy* (2001) is a hard-hitting novel recounting the experience of Alem, a young refugee from Eritrea.

In all his writing Zephaniah's intention is 'to change the world. I'm not a politician . . . so I realise that maybe I can just change people's minds, and get them to think and look at things differently . . . My poetry might not change the world, but it can change people, individuals – and those individuals might change the world.' (Quoted in James Carter, *Talking Books*, 1999.) Among the many causes Zephaniah supports are animal welfare (he is a vegan) and the recognition and provision of help for children with dyslexia.

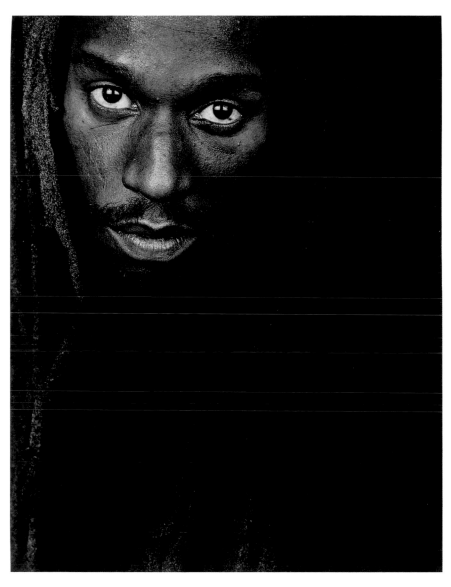

Benjamin Zephaniah, b.1958
Donald MacLellan, 29 August 1996
Toned bromide print, 459 x 355mm (18¹/8 x 14")
National Portrait Gallery (NPG x88746)

JAMILA GAVIN
b.1941

JAMILA Gavin was born in India and for the first five years of her life lived just on the border between India and Pakistan. Her English mother and Indian father lived in India until 1946, when the political situation made it dangerous to stay. Gavin came to England with her mother and brother, while her father stayed behind. The family was reunited in Poona in 1949, but worries about the children's education brought them back to live in England for good in 1953. It was a transition that Gavin found surprisingly easy to manage. Having been brought up with English Christian values she felt entirely at home in Britain and settled into school in London. Her passion was music and she decided to work with music and arts in broadcasting.

Gavin began to write after her own children were born. Reading with them she realised how few books there were that took account of the country's many non-white children. Inspired by a newspaper article that described how black children in a class drew themselves as white in their self-portraits, she wrote *The Magic Orange Tree* (1982), a collection of stories reflecting multicultural backgrounds, including Pakistani, Cypriot and Ghanaian. The emerging market for multicultural books gave Gavin the perfect opportunity to write several other stories for younger readers, often exploring the themes of friendship between children from different cultural backgrounds.

Written for an older audience, *The Wheel of Surya* (1992) is the first in a trilogy that explores the Anglo-Indian relationships of the Partition period, the time of Gavin's childhood. Its starting point is the relationship between an English and an Indian family. The subsequent titles, *The Eye of the Horse* (1994) and *The Track of the Wind* (1997), move away from the domestic and chart the political differences of the time, including the emergence of Sikh terrorism.

Gavin won the Whitbread Children's Book Award 2000 for *Coram Boy*. A chilling but moving account of childhood in eighteenth-century Britain, *Coram Boy was* inspired by her discovery of the fate that befell abandoned children and the role that the philanthropist Thomas Coram played in rescuing them.

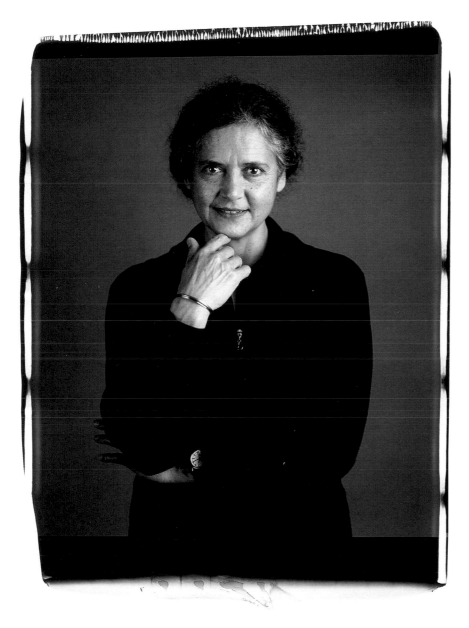

Jamila Gavin, b.1941
Maud Sulter, October 2001
Colour polaroid photograph, 820 x 560mm (32 1/4 x 22")
National Portrait Gallery (NPG P949(4))

Children's changing
expectations

ONE hundred years of writers and one hundred years of readers. Have children changed so much over those years? Do they ask for something else from today's writers?

In a world driven at a different pace and with any number of alternative options, it might seem likely that children's expectations of books would be different but, of all forms of entertainment, books seem to be the most enduring, and the appetite for them appears to be remarkably unchanged. Favourite stories are passed down from one generation to another and although some get lost along the way a great many survive, linking children, parents and grandparents in a shared cultural experience. While many aspects of childhood itself have changed – family structure, attitudes to freedom and, above all, the increase in new technologies as sources of entertainment – the desires of readers have remained remarkably constant. All children from all times want to be entertained by good stories. They want to dream and to travel; they also want to learn and to understand more about the world around them and their own role within it.

While the thirst for stories remains constant, fashions in what those stories are about come and go – but often return, making a full circle. The twentieth century began with children's books only recently released from the moralising tones of Victorian fiction: the sheer escapism of Kenneth Grahame and J.M. Barrie opened up new possibilities and new worlds for young readers. And there was magic, too, in E. Nesbit's *Five Children and It* (1902) and *The Phoenix and the Carpet* (1904).

As the century closed new worlds and magic continued to entrance children, most obviously in Philip Pullman's trilogy *His Dark Materials* and J.K. Rowling's Harry Potter books. These stories of magic and fantasy make

demands on readers, demands to which their audiences rise eagerly. Both Rowling and Pullman write at length, disproving the view that contemporary children have only a short attention span (the result of too much television), and make them think about character, plot and intention – just as Dickens did for the generations before radio and television.

Despite contemporary complaints about children's lack of interest in reading (criticisms that have always been levelled by each generation at the next), children's appetite and enthusiasm for reading seem to be as voracious as ever; and it is not just in the realms of magic. Other strands of storytelling have come full circle within the century, providing as much entertainment in their contemporary form as when they first appeared. Beatrix Potter breathed a new imagination into stories about animals with human characteristics and set off a very British tradition of stories about dressed-up or talking animals that has proved successful ever since. Examples occur throughout the century, with the resourceful animals in Hugh Lofting's *Doctor Dolittle* (1920), Dodie Smith's *The Hundred and One Dalmatians* (1956) and, more recently, Dick King-Smith's *The Sheep-Pig* (1983), among others.

In these well-established areas, children are richly served from both the past and the present. Contemporary experience seems not to change their enjoyment of such satisfying delights. The great scientific advances that have added to our understanding do not diminish the need to imagine and to fantasise. But, just as contemporary life has changed, so the need has developed for stories that reflect and make sense of it. In a world of wall-to-wall media, most of it not aimed directly at children but nonetheless accessible to them, children's books have a vital role to play in interpreting the world around them. Although certainly part of the tradition of children's books as a source of moral information, modern books with a social message are more open-minded. All kinds of family life are shown in the stories and poems of Shirley Hughes, Michael Rosen and Janet and Allan Ahlberg, while Anne Fine and Jacqueline Wilson have charted new territory in their stories of contemporary families and the adjustments and accommodations that need to be made to keep both parents and children happy. Beyond the changes in families, the wider cultural changes in society are made intelligible by such writers as John Agard, Grace Nichols, Jamila Gavin, Benjamin Zephaniah and Malorie Blackman, who have given children from multicultural backgrounds an identity in their books.

The continuing success of storytelling and the remarkably long life expectancy of the best children's books indicate a surprising stability both in children's tastes and in their attitudes to what makes a book worth reading. Despite over 8,000 new children's books being published every year, old favourites remain in print and are still read by each new generation.

Bibliography

GENERAL

Burridge, Jill, and Rosen, Michael, *Treasure Islands 2* (BBC Books, London, 1993)

Cadogan, Mary, and Craig, Patricia, *You're a Brick, Angela!* (Gollancz, London, 1976)

Carpenter, Humphrey, *Secret Gardens: The Golden Age of Children's Books*
 (Allen & Unwin, London, 1985)

Carpenter, Humphrey, and Prichard, Mari, *The Oxford Companion to Children's Literature*
 (Oxford University Press, Oxford, 1984)

Carter, James, *Talking Books* (Routledge, London, 1999)

Chambers, Aidan, *Booktalk* (Bodley Head, London, 1985)

Chevalier, Tracy (ed.), *Twentieth-century Children's Writers*, 3rd edition (St James Press, Chicago
 and London, 1989)

Cook, Helen (ed.), and Styles, Morag (ed.), *There's a poet behind you . . .*
 (A & C Black, London, 1988)

Goldthwaite, John, *The Natural History of Make-Believe* (Oxford University Press,
 Oxford and New York, 1996)

Home, Anna, *Into the Box of Delights: A History of Children's Television* (BBC Books,
 London, 1993)

Hunt, Peter, *An Introduction to Children's Literature* (Oxford University Press, Oxford, 1994)

Landsberg, Michele, *The World of Children's Books* (Simon & Schuster, London, 1988)

Martin, Douglas, *The Telling Line* (Julia MacRae Books, London, 1989)

Moss, Elaine, *Part of the Pattern* (Bodley Head, London, 1986)

Rustin, Margaret and Michael, *Narratives of Love and Loss* (Verso, London, 1988)

Schafer, Elizabeth D., *Exploring Harry Potter* (Ebury Press, London, 2000)

Townsend, John Rowe, *Written for Children* (Penguin, London, 1986)

Turner, E.S., *Boys Will Be Boys* (Michael Joseph, London, 1975)

Watson, Victor, *Reading Series Fiction* (RoutledgeFalmer, London and New York, 2000)

Wullschläger, Jackie, *Inventing Wonderland* (Methuen, London, 1995)

1900–1920

Birkin, Andrew, *J.M. Barrie and the Lost Boys* (Constable, London, 1979)

Cadogan, Mary, *Frank Richards: The Chap behind the Chums* (Viking, London, 1988)

Freeman, Gillian, *The Schoolgirl Ethic: The Life and Work of Angela Brazil*
 (Allen Lane, London, 1976)

Prince, Alison, *Kenneth Grahame: An Innocent in the Wild Wood* (Allison & Busby, London, 1994)

1920s & 1930s

Cadogan, Mary, *Richmal Crompton: the Woman Behind William* (Allen & Unwin, London, 1986)

Carpenter, Humphrey (ed.), *The Letters of J.R.R. Tolkien* (Allen & Unwin, London, 1981)

Hale, Kathleen, *A Slender Reputation: An Autobiography* (Frederick Warne & Co., London, 1994)

Hardyment, Christina, *Arthur Ransome and Captain Flint's Trunk* (Jonathan Cape, London, 1984)

Hart-Davis, Rupert (ed.), *The Autobiography of Arthur Ransome* (Jonathan Cape, London, 1976)

Milne, Christopher, *The Enchanted Places* (Methuen, London, 1974)

Pearce, Joseph, *Tolkien: Man and Myth* (HarperCollins, London, 1998)

Thwaite, Ann, *A.A. Milne – His Life* (Faber and Faber, London, 1990)

1940s & 1950s

Bond, Michael, *Bears & Forebears* (HarperCollins, London, 1996)

Lewis, C.S., *Surprised by Joy: The Shape of My Early Life* (Geoffrey Bles, London, 1955)

Nettell, Stephanie, interview with William Mayne in *Books for Keeps*, July 1990

Sibley, Brian, *The Thomas the Tank Engine Man* (Heinemann, London, 1995)

Sutcliff, Rosemary, *Blue Remembered Hills: A Recollection* (Oxford University Press, Oxford, 1988)

1960s & 1970s

Briggs, Raymond, *Ethel & Ernest* (Jonathan Cape, London, 1998)

Dahl, Roald, *Boy: Tales of Childhood* (Jonathan Cape, London, 1984)

—, *Going Solo* (Jonathan Cape, London, 1986)

Postgate, Oliver, *Seeing Things: an autobiography* (Pan Macmillan, London, 2001)

Pullein-Thompson, Josephine, Christine and Diana, *Fair Girls and Grey Horses: Memories of a country childhood* (Allison & Busby, London, 1996)

Treglown, Jeremy, *Roald Dahl* (Faber and Faber, London, 1994)

1980s & 1990s

Blake, Quentin, *Words and Pictures* (Jonathan Cape, London, 2000)

Lloyd, Errol, interview with Benjamin Zephaniah in *Books for Keeps*, July 1998

I would like to thank the following publishers for their help: Bloomsbury Children's Books; Egmont Children's Books; Frederick Warne & Co.; HarperCollins Children's Books; Hodder Children's Books; Macmillan Children's Books; Oxford University Press; Penguin Books; Puffin Books.

Index

Picture credits

Frontispiece and p.12 (top): Copyright © Frederick Warne & Co., 2002; p.11: Copyright © Frederick Warne & Co., 1902, 1987. Reproduced with kind permission of Frederick Warne & Co.; p.12 (signature): © Frederick Warne & Co.; p.21: © Hulton Archive; pp.23, 37, 45, 59, 67 & 89: © Reserved; pp.26–7: © Christopher Lofting. All Rights Reserved; p.29: © By kind permission of Chris and Muriel Laming, photograph courtesy of Canterbury Museum; pp.33–4: Copyright A.A. Milne and E.H. Shepard, reproduced by permission of the Trustees of the Pooh Properties and the Estate of E.H. Shepard; p.43: © Simon Hughes-Stanton and Judith Russell, children of the artist; p.49: © Noel Streatfeild Estate; p.51: © Photograph: Snowdon; p.53: © PA Photos; pp.55–6 (Noddy illustration and manuscript): © Enid Blyton Limited (A Chorion Company) (All Rights Reserved); p.56 (signature): ™Enid Blyton Limited (A Chorion Company) (All Rights Reserved); p.61: © Trevor Ray Hart; pp.63 & 97: © Duncan Fraser; p.65: © Arthur Strong; p.69: © John Timbers; p.71: © Carole Cutner Photography; p.73: © Don Bachardy; p.77: © Helen Craig; p.81: Copyright Quentin Blake; p.82: Loaned by the Roald Dahl Museum Trust © RDNL; p.83: © Jan Baldwin; p.85: © Henri Cartier-Bresson/Magnum Photos; p.87: © photographer: James Styles; p.91: © Photo Mark Gerson; p.93: © David Bennett; p.95: © Sam Barker; p.99: © 1997 Beth Gwinn; pp.101–2 (book covers): Courtesy of Bloomsbury Children's Books; p.102 (signature): © J.K. Rowling™; p.103: © Murdo MacLeod; p.105: © Photograph by Jason Bell; p.107: © Martin Salter/Penguin; p.109: © Photo by Michael Dyer; p.110: From *Peepo!* by Janet and Allan Ahlberg, published by Penguin Books Ltd; p.111: © Photography Glyn Williams; pp.113 & 117: © Cinnamon Heathcote-Drury; p.115: © Clara Vulliamy; p.125: © Eamonn McCabe; p.127: Donald MacLellan ©.

Michael Bond Philippa Pearce Roald Dahl Ted Hughes Oliver Postgate Leon Garfield Richard Adams Nina Bawden Josephine, Christine and Diana Pullein-Thompson Raymond Quentin Blake Michael Rosen Briggs Joan Aiken J.K. Rowling